FIREGHOSTS

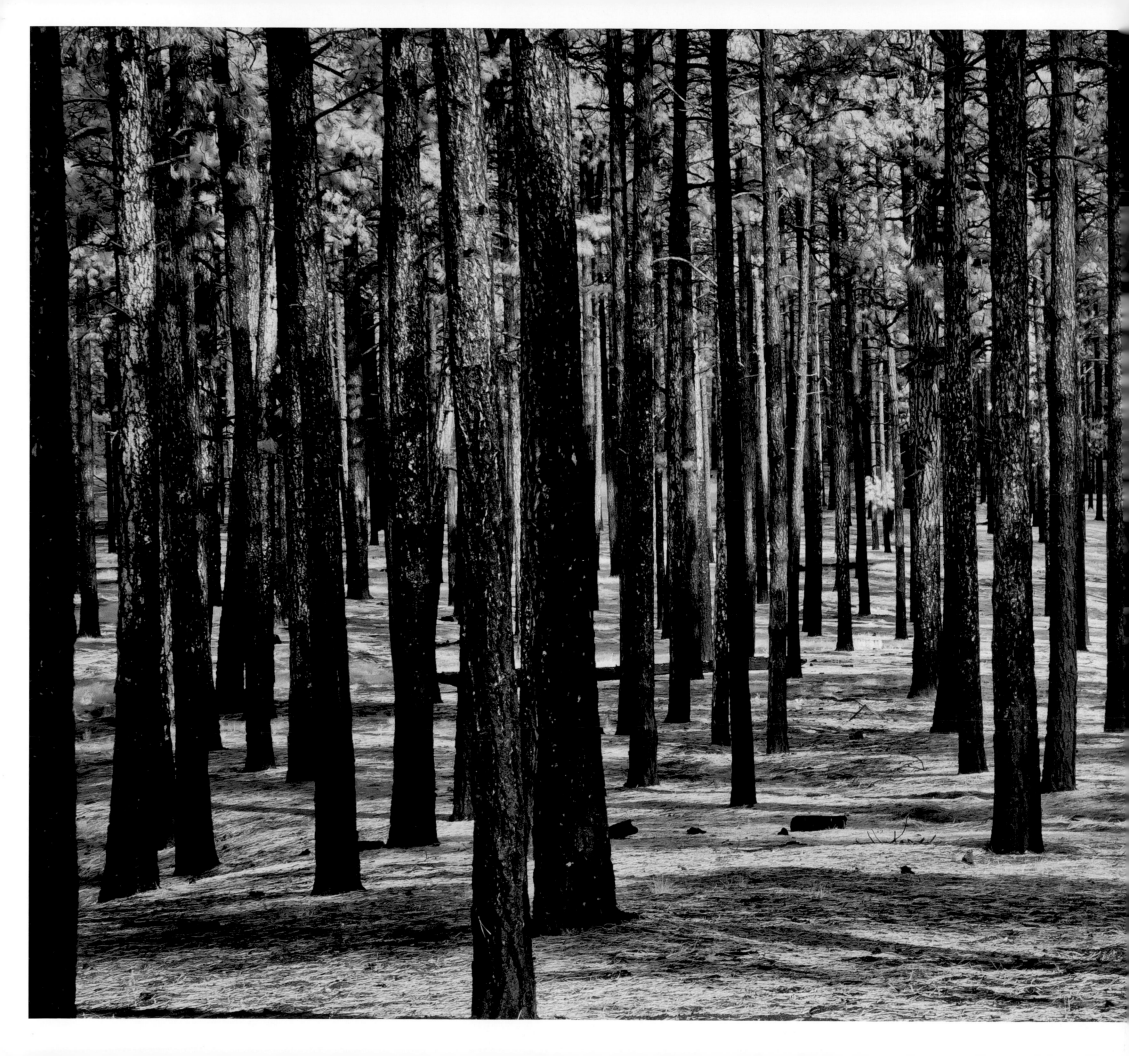

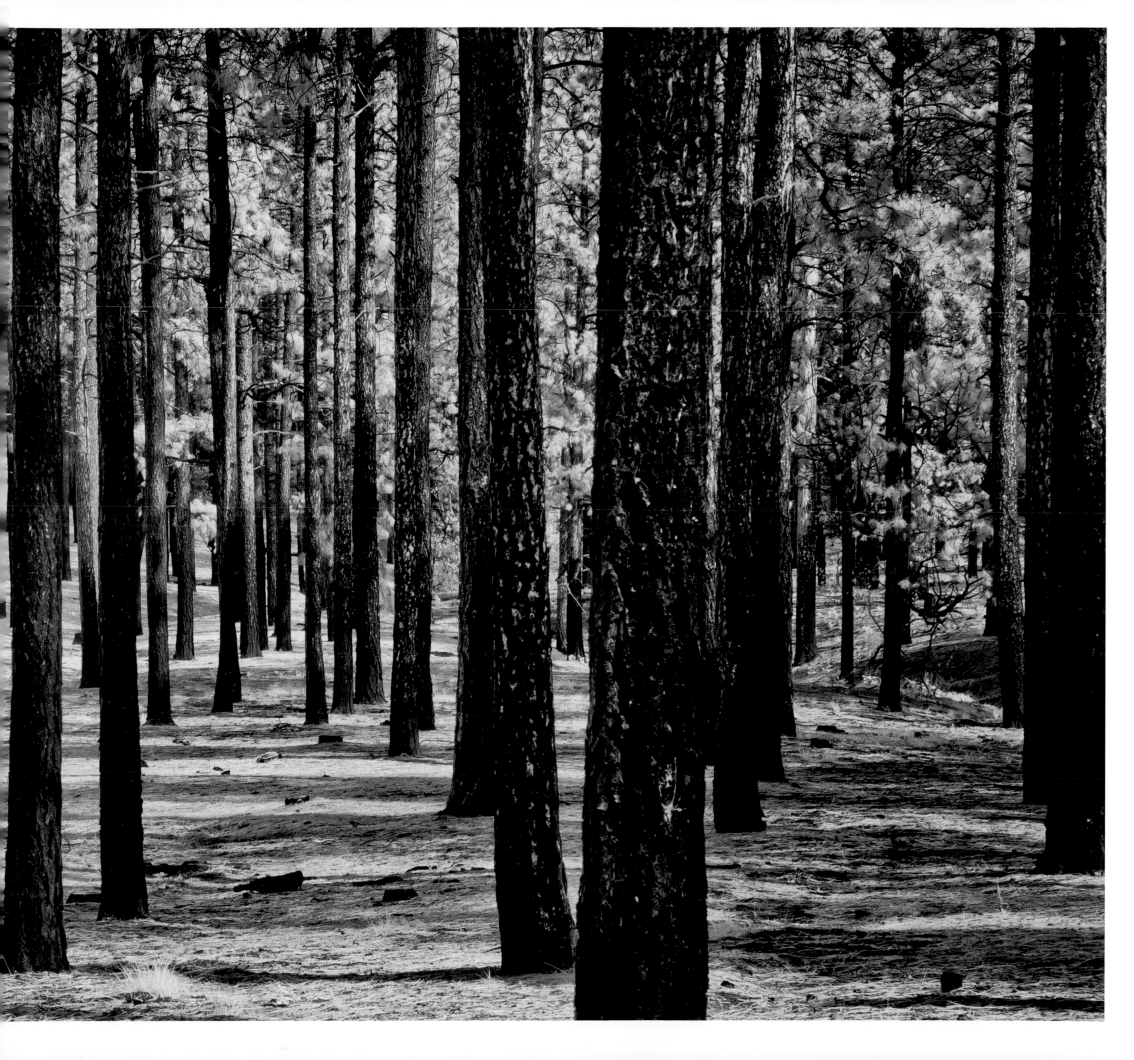

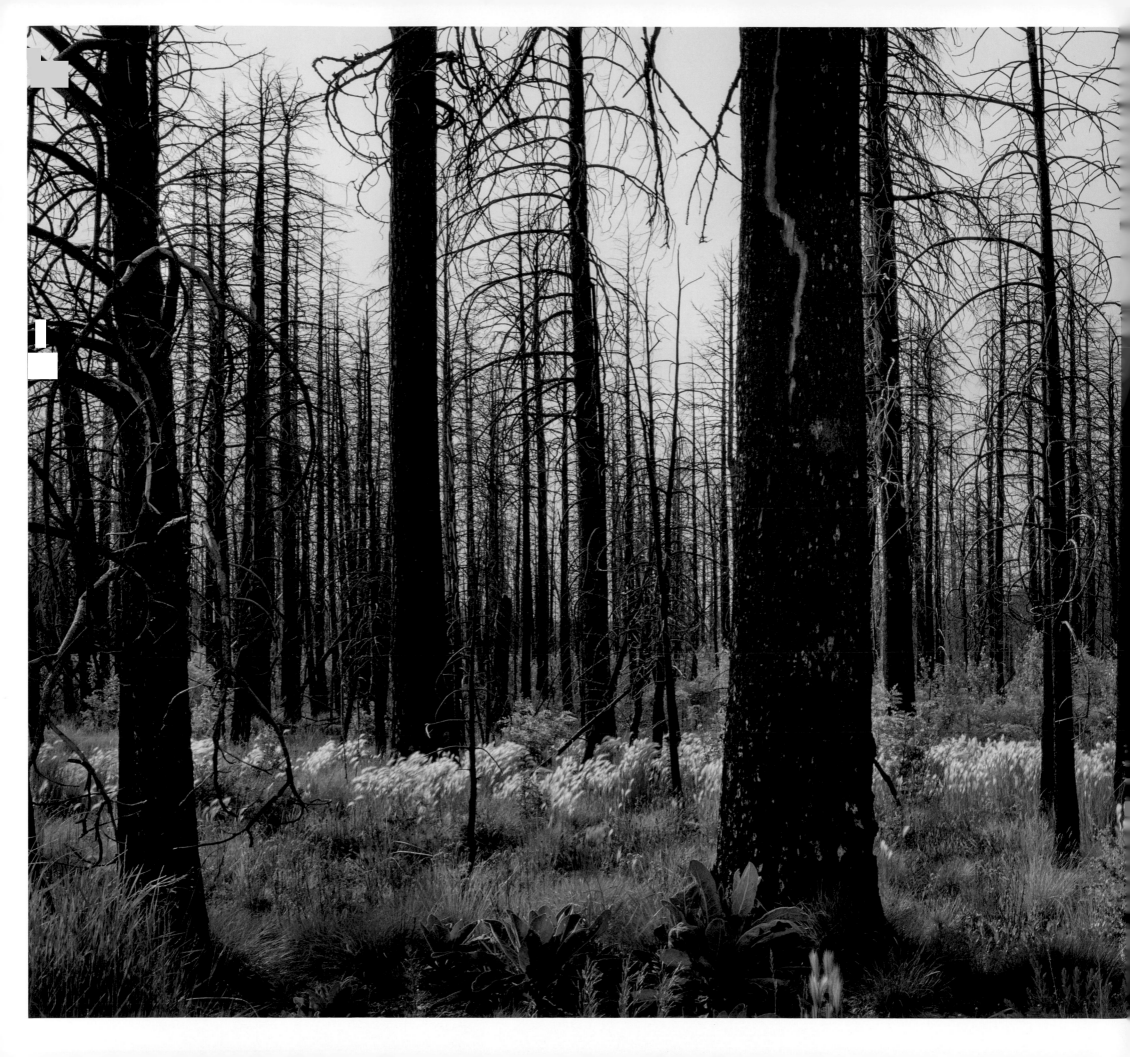

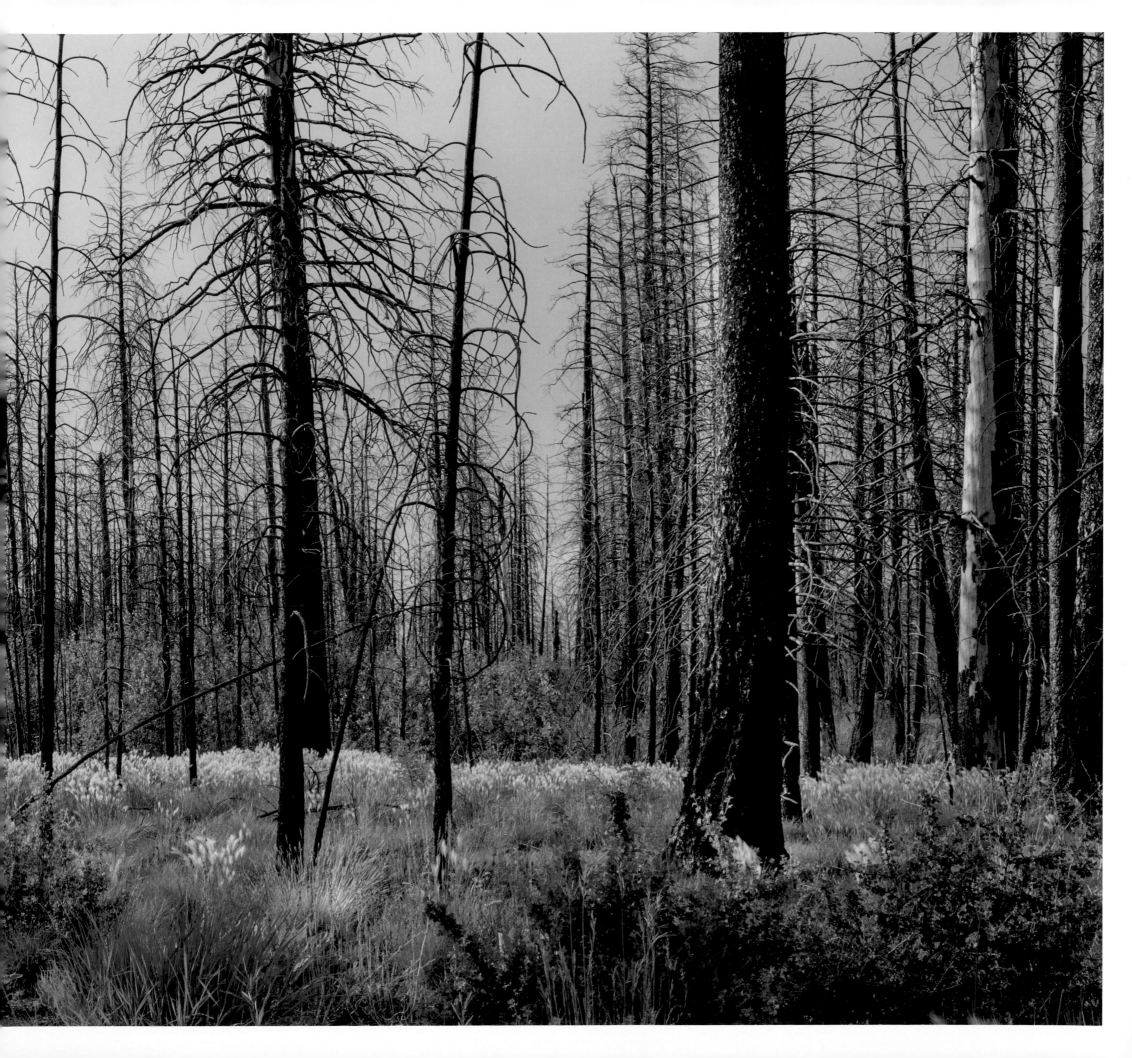

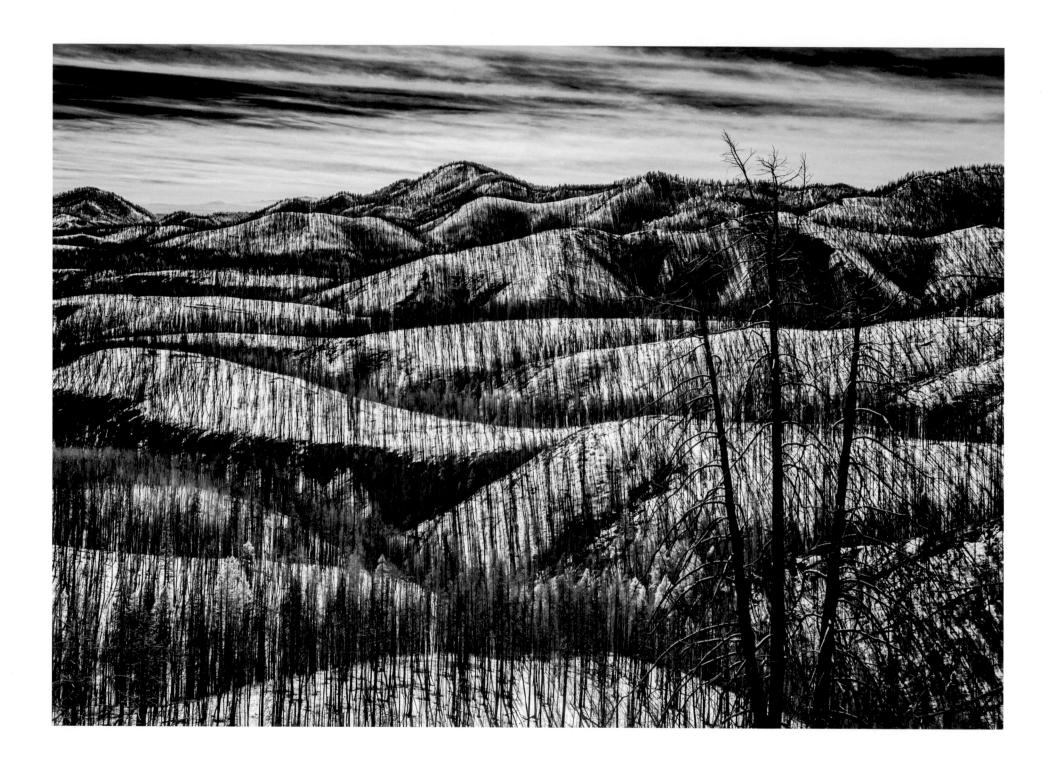

VIEW FROM COCHITI MESA

FIREGHOSTS
PHILIP METCALF AND PATRICIA GALAGAN

INTRODUCTION BY

Katherine Ware

ESSAYS BY

William deBuys
Craig D. Allen

George F. Thompson Publishing

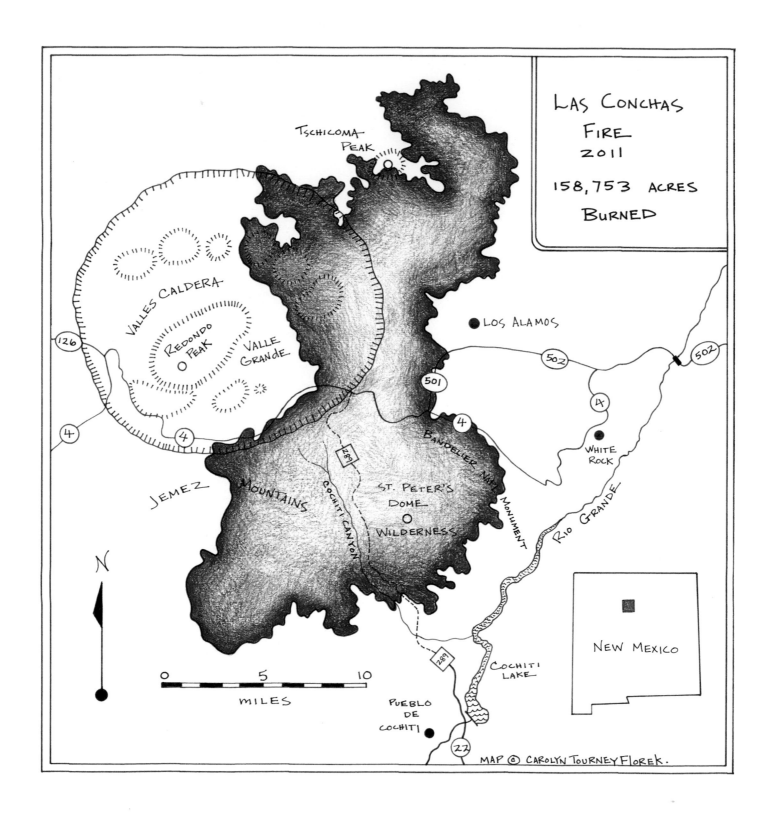

LAS CONCHAS
FIRE
2011

158,753 ACRES

BURNED

Tschicoma Peak

VALLES CALDERA

REDONDO PEAK

VALLE GRANDE

126

4

LOS ALAMOS

502

502

501

4

4

WHITE ROCK

289

JEMEZ MOUNTAINS

COCHITI CANYON

ST. PETER'S DOME

WILDERNESS

BANDELIER NAT'L MONUMENT

RIO GRANDE

N

0 5 10
MILES

289

COCHITI LAKE

NEW MEXICO

PUEBLO DE COCHITI

22

MAP © CAROLYN TOURNEY FLOREK.

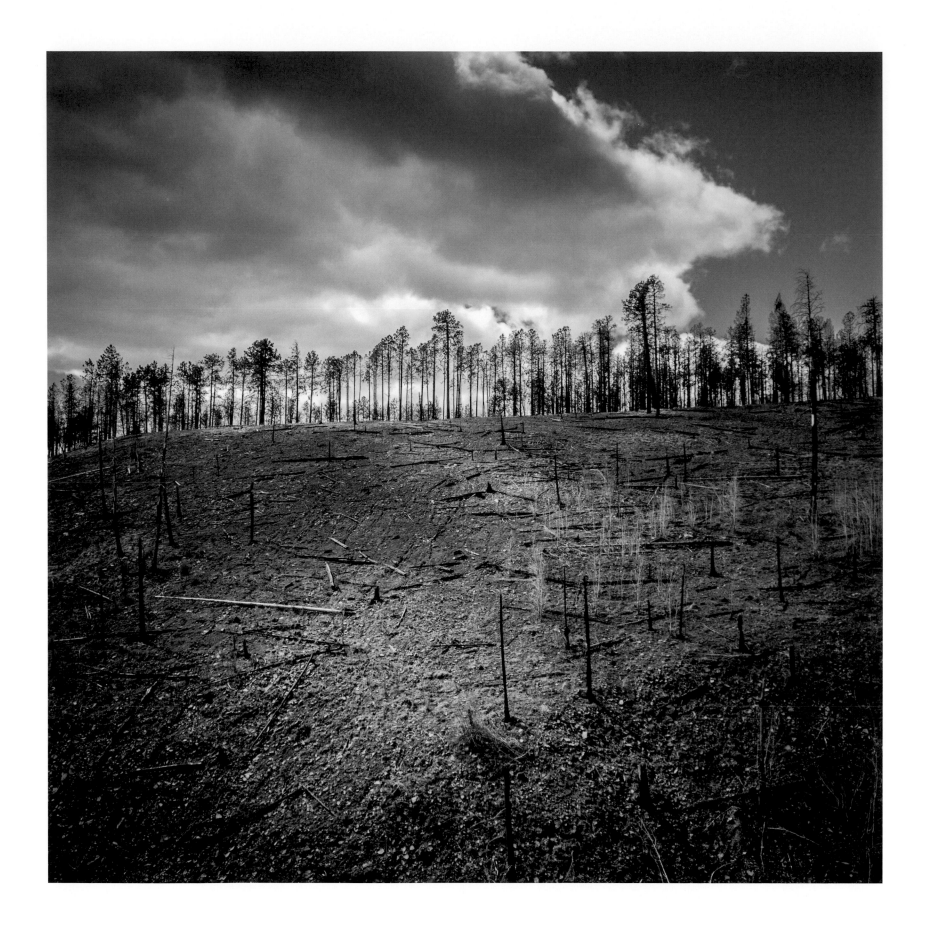

VIEW FROM NEW MEXICO ROUTE 4

by Patricia Galagan and Philip Metcalf

IN THE SUMMER of 2011, in the Jemez Mountains of northern New Mexico, a falling power line sparked a wildfire that burned 158,753 acres of forest. From our home, thirty air miles southeast, we watched the Las Conchas Fire burn day and night for more than a month.

As soon as the roads reopened, we went to the mountains to see what a violent forest fire had done to a familiar place. We took a trail to the rim of Cochiti Canyon, passing through sections of forest that had burned so hot that nothing remained but blackened trunks and negative spaces where huge tree roots had been. The canyon and the waves of ridges beyond were black with standing dead trees. We felt we were gawking at a terrible accident.

The visual chaos of the burned forest, at first daunting, pushed us to look harder, to see differently. The forest began to look beautiful in its highly altered state. We discovered ourselves trying to make compelling photographs of a terrible thing to draw people beyond the news-cycle images of smoke and flames and carnage into the transformed reality of a forest in the aftermath of an extreme fire.

We traded our city car for a second-hand, off-road vehicle that could take us deeper into the burn. And we kept returning through all seasons and all weathers for the next seven years. As our work progressed, so did the frequency and severity of forest fires in the western United States. With each new fire, we realized that our photographs revealed the new future for burned forests everywhere.

This project has been a lesson in incremental seeing. The new growth that began in the forest almost immediately after the fire hinted at restoration. But when we showed our photographs to forest ecologist Craig Allen, he told us about the science of burned and water-starved forests and their likely future in an era of accelerating climate change. We had to stop thinking that the new forest would be a restored copy of the one that burned. It would never be.

Susan Sontag once wrote, "All photographs are momento mori."[1] In the most direct sense, our photographs are about the death of a forest—a sudden, violent death by fire of things we count on a forest to embody: color, scent, coolness, shadow, order, continuity, beauty. Our work depicts a process that began with death but moved quickly to this and other forests' most essential task in our time—adaptation to a hotter, drier world.

1. Susan Sontag, *On Photography*, (New York, NY: Farrar, Straus and Giroux, 1977), 15.

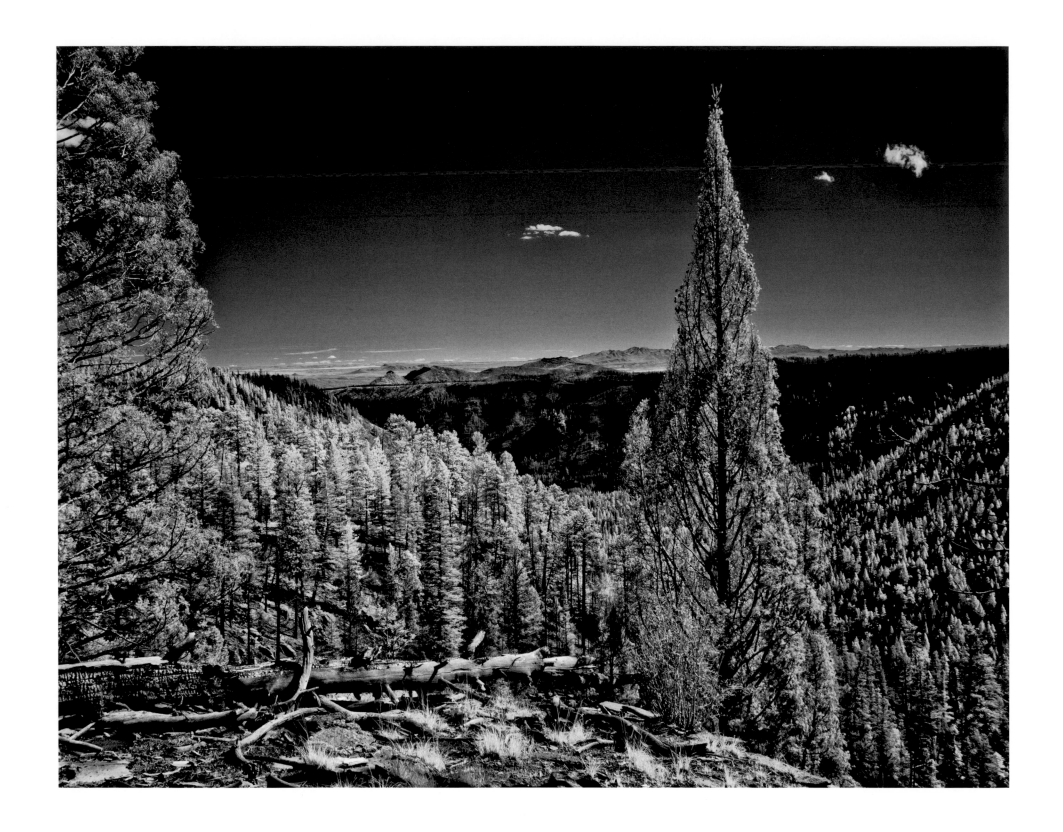

NORTH RIM, UPPER FRIJOLES CANYON

ALTERATION AND ADAPTATION

Katherine Ware

A KEEN SENSE OF HUMAN INCONSEQUENTIALITY can be one of the unexpected pleasures of being in the great outdoors. The landscape before us—whether forest, field, or escarpment—continues to function and evolve without our assistance or any regard to our daily tribulations. While many of our kind enjoy the illusion of a world with themselves at the helm, others take pleasure and even comfort in being part of an ever-shifting process that transcends the individual and even the species. Change is a constant in the natural world, although it often happens slowly in relation to human time. We dwell among rocks formed by ancient volcanoes and among mature trees that began as seeds, aspiring to the sky for decades. The starry sky, the rhythmic rivers, and the many landmarks of our terrestrial world predate us, as we shall predecease them.

Even so, there is no mistaking the cumulative impact of human interventions on many of the landscapes we thought would outlast us. Climatic disruptions of frequency, scale, and intensity are increasingly difficult to ignore. Patricia Galagan and Philip Metcalf have used their cameras to chronicle this type of accelerated change as it unfolds in their part of the world, in a forest in the Jemez Mountains near Los Alamos, New Mexico, that was largely obliterated by the Las Conchas Fire in the summer of 2011. Initiated by a downed power line, it developed into a super fire of great intensity, setting an unfortunate record as the hottest and longest-burning fire in the state's history. From their liv-

ing-room windows in Santa Fe, the artists watched as the fire unfolded fifty miles away as a vivid catastrophe of prodigious clouds of smoke and massive bursts of flame. When it was finally over and the burned area was no longer restricted, they packed up their gear and headed for the mountains to see for themselves what might possibly remain.

In contrast to the spectacle of the fire, its aftermath was subdued and stark. In place of the robust pine, spruce, and fir forest were acres of ash punctuated by jagged tree trunks and debris, a foreign world of brown, grey, and black. Stunned and saddened by this drastic shift, Galagan and Metcalf turned their cameras on the scene before them, bearing witness to the transformation as well as trying to comprehend it. As they returned over months and then years, their individual visions of the site and its nuances began to emerge in their pictures, resulting in two different but complementary bodies of work. Joined together in this book, these images articulate the artists' emotional and intellectual journey from the initial shock of losing a beloved landscape, to the guarded hope of its eventual return, and finally to their growing realization of the massive degree of change.

As a landscape photographer working in black-and-white, Philip Metcalf was well situated to tackle the aftermath of the fire and the almost monochromatic palette of the burned hillsides. In his initial work at the site, he gravitated toward the forms of the remaining tree trunks suddenly made visible without the surrounding forest. In

some images, scorched sentinels rise to jagged points or reach toward the sky with seemingly anthropomorphic branches. In others, whole mountainsides of denuded trunks are portrayed as violent black slashes that signify the cancellation of the forest.

Working within the popular tradition of twentieth-century photography that celebrates the wonders of the natural world, Metcalf also plays on our expectation of a beautiful view. Drawing on the visual tension between the familiar and the unexpected, many of his pictures show the land receding bountifully into the distance with fluffy white clouds above; yet when we look more carefully, we notice not the anticipated storybook forest but an unwelcome charred wasteland. Deeply affected by the strangeness of the altered views around him, Metcalf decided to shoot in infrared to heighten for the viewer the disorienting sensation he experienced, lending the images from his series, *Forest Elegy*, a distinct aura of unreality.

If the fire itself marks the beginning of this story, then Metcalf's charcoal spires and eerie vistas represent the middle chapters, showing what is left after the epic plumes of smoke and ash-laden air have settled. In this bleak landscape, Patricia Galagan also began making images of the lost forest. Her practice of working in both black-and-white and color and with a variety of subjects left her with the more open questions of how to approach this place and of what part of the story she would tell. Finding nothing there to steer her toward color, she initially focused on the dark subject of the burned trees.

After numerous visits, however, Galagan noticed inklings of green as plant life began to appear at the base of some of the blackened trunks. This new growth seemed to offer the welcome promise of renewal, so Galagan decided to adopt the lifecycle of the forest as her theme. Still portraying the landscape in its largely muted tones, she started highlighting small areas of life in green and yellow to signal the rejuvenation of the forest, aligning her images with the future of the site rather than its past. To honor this enduring spark of life, she titled her series *The Green Fuse*, from a line in a Dylan Thomas poem.

Keeping the ever-present burned trees in her sights, Galagan began to shift her palette away from the predominant grey as they were joined by smatterings of resilient plant life. Within five to six years, she was showing a relatively colorful flourishing of shrubs and native grasses interspersed with mullein and wildflowers, albeit with blackened trees in their midst. By then it was apparent that the chapter she was photographing was not about regrowth but about succession. The plants thriving in the ashes of the pine forest were not the same as the slow-growth conifers around whose charred remains they sprouted. Instead, the site was being colonized by vegetation better adapted to extreme fires and a warming climate, such as aspens, locusts, shrubby oaks, and many grasses, all of which have roots that can survive the fire passing above and regrow to establish a different ecosystem. She had captured the new normal.

The most famous landscape photographers of the early-twentieth century—among them Ansel Adams and Eliot Porter—chose to emphasize the beauty and variety of the world's wondrous topography. Their images were meant to inspire appreciation and protectiveness toward the planet that sustains us and a recognition that our actions upon it are not without consequences. By the late 1960s and early 70s, photographers began shifting away from this emphasis on "wilderness" and "unspoiled" beauty toward showing clear evidence of human impact on the land. Almost fifty years later, in the twenty-first century, photographers, including Galagan and Metcalf, are depicting signs of a much deeper disruption.

Back in northern New Mexico, the mesas and mountainsides will thrive again, but the forest of pines is diminished, will shrink, and perhaps disappear as the landscape grows drier and warmer and fires become more frequent. The pace of change around us is now noticeably accelerated. The images in this book are a reminder that we would do well to match that pace in adapting our behavior.

THE TESTIMONY OF THE TREES

William deBuys

WE USED TO WORRY a lot about the Jemez Mountains, *we* being the disputatious community of environmentalists, land managers, and interested citizens involved in what we flattered ourselves to call the "management" of the mountain range. The Jemez range, clad (at least formerly) in rich conifer forests, rises in north-central New Mexico amidst Indian Pueblos and Hispanic villages that long pre-date America's nineteenth-century conquest of the region. The mountains also tower over a relatively young city of considerable, if dubious, fame: Los Alamos, the birthplace of the atomic bomb. At the top of the range sprawls one of the most magnificent landscapes of the American West, a collapsed volcanic field called the Valles Caldera, a basin of vast, tawny grasslands and dark, dome-shaped mountains, which not a few Hollywood producers, as well as myth-makers for Marlboro cigarettes and Stetson hats, have deemed so iconically Western that they staged their movies and advertisements there.

Given the diversity of interests and values that people impute to the mountains, as well as the value of their timber, grazing, and recreational resources and the land's downright jaw-dropping beauty, the Jemez gave us plenty to worry about.

We worried about the forests, which had become unnaturally dense with trees after a century or more of fire suppression. The resulting concentration of woody fuels gave everyone, including experienced fire-fighters, the jitters.

We worried—and litigated—about what thinning those fuels would do to the forest's most vulnerable creatures, not least the Mexican spotted owl, a federally protected species.

We even worried about the trees that weren't there, for young aspen had become scarce in the Jemez. Mature aspen were still plentiful, but they were failing to reproduce because a burgeoning elk population browsed down any shoots that tried to come up. As for the elk, we worried that the herd might get too big for its available habitat, with the ranchers among us arguing that such was already the case. Elk, they said, were eating the grass their cattle needed.

When the weather turned dry and the Dome Fire blew up in 1996, consuming 16,516 acres in an extremely fast-moving, explosive blaze, we worried that we might be seeing the start of something really troublesome. Four years later, the Cerro Grande Fire confirmed those fears by roaring across the eastern face of the mountains, causing the evacuation of Los Alamos and reducing a portion of the city to ashes (but sparing the nuclear lab). The Cerro Grande Fire also distracted us with a new worry: Who really set the disastrous fire? Was it the result of a botched prescribed burn started by the National Park Service or were the flames that engulfed Los Alamos descended from ill-considered back-fires set by outside fire crews to control what the Park Service had started?

Fifteen years later, the Las Conchas Fire put an end to that kind of fretting. By then I had developed especially strong feelings for the Jemez. Not only had I played a small role in issues relating to the mountains through the 1980s and 90s, but when the federal government bought the Valles Caldera from private owners in 2000 and created the Valles Caldera National Preserve, I wound up chairing the experimental organization—the Valles Caldera Trust—that the U.S. Congress charged with administering the 87,000-acre preserve. Although my term of service ended in 2005, long before the Las Conchas Fire erupted, my attachment to these mountains never diminished. When the Las Conchas Fire swept over the Jemez, burning deep into the caldera, I felt the losses personally. Oddly, however, I also felt a sense of relief. It was as though the fire cracked open my worry like an over-heated boulder and split it in two. The accumulated worry seemed to vaporize in the heat. Left behind were new emotions, equal parts sorrow and wonder. These feelings infuse the photographs that fill this volume—sorrow for a world destroyed and wonder both for the power that consumed what used to be and for the novelty and frequent beauty of what came after.

I was at my desk at home, in El Valle, a small village on the High Road to Taos, forty miles from the Jemez, when the fire broke out on June 26, 2011. The afternoon was hot, dry, and windy, and the fire season had already produced smoky skies for days, if not weeks. I opened an email from an ecologist friend. She said that a particularly nasty burn seemed to be developing in the Jemez. I went outside. Sure enough, off to the southwest, right where I'd seen the plume of the Cerro Grande Fire in 2000, dark clouds billowed into a blue sky.

Because I live in a valley where ridges block the view, I could see only a hint of what the far horizon might reveal, yet it was clear that something massive was unfolding. I gathered binoculars, a spotting scope, a tripod, and a camera. I drove ten miles to a highway turnout at the village of Truchas, which perches on a shoulder of the Sangre de Cristo range, affording a sweeping, unobstructed view across the broad valley of the Rio Grande.

The Jemez Mountains, bounding the valley on the west, are volcanic by origin. Now they seemed to be erupting again, spewing an immense column of smoke into the sky. The smoke spread before the wind, rising beyond the altitudes where jetliners fly. Its dark pall drew a sooty curtain across half the sky, rendering the day eerily dark, like a partial eclipse. I parked my truck rearward toward the view, let down the tailgate, set up the tripod and scope, and settled in to watch.

Later investigation established that the fire broke out about 1:00 pm. My earliest photographs show a time stamp of a few minutes past three. In them the fire's plume, white at the edges and black at its core, rises from the Jemez horizon like an immense distorted mushroom. Its foot was already miles wide, planted on the mountain. A steady wind pushed the plume eastward over the Rio Grande Valley, until it merged with smoke from a second fire in the Sangre de Cristo range, close to Santa Fe, which had been burning already a week or more. In some of the photographs, you can see the red eye of the sun vainly peering through the billows.

White smoke signifies combustion that is complete, leaving only ash. Black smoke denotes a fire in chaos. The blackness consists of incompletely burnt, volatilized material, a forest atomized into tiny parts and discharged, only half consumed, into the air. The dark stem of the Las Conchas plume was angry, turbulent, and orders of magnitude thicker than the largest conceivable tornado. Most startling were the red lightnings that flashed up the column as combustion continued for thousands of feet into the sky, burning the micro-fuels that the fire's violence churned upward.

Periodically I also saw patches of intense white light flaring in front of the fire. These were spot fires, ignited by flaming aerial brands that the convective gale of the fire lobbed forward. The spot fires burned with a white smoke but not for long. Ferociously they consumed the bone-dry forest, and their smoke darkened from white to brown and from brown to black. Then the advance of the mother conflagration absorbed them, growing ever larger until the entire range seemed dwarfed by the smoky ghost of itself that boiled into the sky.

The hour and a half that I watched the fire included the apex of its fury. As Craig D. Allen points out in his essay in this book, the Las Conchas Fire consumed 43,624 acres of forest in its first fourteen hours. Such a rate of spread, if

you do the math, means that the fire gulped down an acre of forest *every second*, on average, from the moment of its ignition until deep into the night. Before such vehemence trees virtually explode. Even from forty air miles away, where I sat on the tailgate of my truck, the spectacle was astonishing. Spot fire after spot fire leapt in front of the stalk of the plume, and the stalk progressively grew thicker and darker, becoming a trunk, then a pillar, then a colossus, while the day dimmed to premature night.

It is well known that, on an oxygen planet, things will burn. In the Las Conchas Fire, our oxygen planet strutted its stuff as flagrantly as the laws of physics allowed.

Post-fire inspections revealed a series of marvels. One stand of pines—all of them utterly dead—still retained their needles, which somehow the fire had not consumed. The needles were "frozen" horizontally—pointed downwind—and intact. One hypothesis holds that the gale that blew through the stand was devoid of oxygen, every molecule of which had been consumed in some upwind furnace of combustion. As a result, the "air" that mummified the trees could no longer oxidize (i.e., burn) trees or anything else. Instead, the super-heated blast, hot beyond imagining, flash-killed every biological thing in its path.

Elsewhere, clumps of shrubs and isolated trees on cliffside ledges were found reduced to heaps of ashes. These were locations surrounded by bare rock, with no trail of combustible fuel, whether grass or wood, linking them to any other burnable place. These islands of ash testified to a contagion of heat and flame that spread like the shock wave of a bomb.

For months after the fire, more marvels followed. Thunderstorms striking scorched slopes triggered erosion that filled crystalline creeks and rivers with gravel in mere hours, while lakes of ashy sludge collected wherever the land flattened. Years earlier I had taken an expert in moss ecology to one of the now-obliterated rivulets in the Valles Caldera. On hands and knees he closely examined the incised channel of the rivulet, which was rendered almost invisible by tall grasses bending above it. He parted the grasses, plucked samples of moss from the humid edge of the rivulet, and peered at them through a hand lens. With a cry of delight he declared that one such sample was a species of moss he'd

never before seen in the wild. So sensitive was it to the chemistry of its surroundings, he said, that in his lab at the Missouri Botanical Garden he managed to grow it only with distilled water. Such was the former purity of the caldera's Rito de los Indios.

After the Las Conchas Fire, I visited the creek and with difficulty found the site where my friend had identified the moss. The channel of the Rito was essentially erased, packed densely with outwash from the storm-torn slopes above it. No longer did the Rito de los Indios have space for a fern or a fish, let alone a delicate moss.

Not far away, at the southern foot of Cerro del Medio, one of the inner mountains of the caldera, the erosion was even more spectacular. Runoff from scorched slopes had carved arroyos deep enough to hide a house in. The new gullies led to the very edge of the fabled Valle Grande, the largest of the caldera's grasslands, where the force of the storm-driven waters had uprooted and washed out whole ponderosa pines and thrown them into jackstrawed heaps.

The Valle Grande had changed, too. Its magic has always seemed to reside in the bowl-like perfection of its grassy distances and in the dark uniformity of the forested slopes that form its rim. Now it wears a different look, especially toward the east where pincushion mountains mark the skyline, the pins being the sentinel carcasses of burned trees. The sight is sobering, alarming, cautionary, and sometimes also beautiful, as you see in the images by Galagan and Metcalf herein.

The losses are painful, but the recovery, at least at the higher elevations where snow and rain are sufficient to fuel new life, possesses the power to amaze. Robert Parmenter, Director of Science for the Valles Caldera National Preserve, predicts that, in years to come, tourists from far and wide will venture to the Jemez Mountains to revel in the autumn splendor of new generations of aspens. The tremulous, white-barked trees, which turn golden in the fall, have established themselves across thousands of acres of burned slopes that were previously dark with spruce. Rising from vast networks of interconnected roots, the aspen have sprouted so prolifically that not even ten times the present number of elk could chew them away. The elk, meanwhile, have no complaints. Their population is swelling into newly

opened expanses of shrubs and grass. A human observer may regret the charred, new vistas, but from the point of view of a hungry ungulate, they look like Eden itself.

So maybe things aren't so bad, we say to ourselves. The landscapes of the past were rich and beautiful, and those of the future can be rich and beautiful, too. Ought we not cut loose the anchor of our past attachments and release ourselves into the currents of the future?

Certainly we need to make the best of things, and the prospects now before us have the potential to please in many ways. Unfortunately these new conditions are likely to change again. This is the new reality of the Anthropocene. We've stopped treading the firm, familiar ground of the Holocene epoch, the previous period of roughly 10,000 years that favored human advancement with a stable global climate. Our penchant for burning the forests of the deep past—remade as coal, oil, and gas—guarantees that the forests of the present will burn with a destructive vigor unprecedented in any history that we directly know. As I write, the body count of the murderous Camp Fire, which swept through Paradise, California, in November 2018, with a vehemence comparable to that of the Las Conchas Fire, remains incomplete at 88, with 249 persons still missing. Local authorities have called in anthropologists and other forensic experts for assistance in extracting DNA from fragments of charred bones.

We find ourselves at the beginning of a new era that will challenge us in myriad ways, and the Las Conchas Fire may fairly be seen as evidence of its commencement. Our failure, thus far, to change our fossil-fuel consumption means that there is as yet no upward limit to the amount of global heating our habits may produce. Worse, the matter may soon be out of our hands. One common scenario holds that if reservoirs of methane previously locked in arctic ice give up their carbon to the air, the forward jolt they impart to global warming may negate any new discipline we muster. And that is only one of several scenarios for runaway

warming. Indeed, for some scientists the tipping point may already have passed, given the evidence and momentum for change already embedded in the global climate system.

So the aspen splendor of the future Jemez Mountains may be brief but not because aspen, as trees go, are short-lived. It may be brief because the conditions that permit aspen to occupy the higher reaches of the Jemez will themselves be fleeting. Generation by generation, the climatic parameters that shape the ecological world in the West and elsewhere are liable to shift, probably a good deal more and a good deal faster than at any time since human beings have existed. And fire will not be the only vector of change. Insects such as the harmful bark beetle will have their say, too, as higher temperatures boost their populations, shift their ranges, and alter their relationships with the tree species on which they feed. And, oh yes, out-and-out drought and heat will take their toll as well, even absent the drama of conflagration.

The present moment is undoubtedly a good time to enjoy what now exists, for the things we like may not exist for long. It is a good time, too, to fasten one's metaphorical seatbelt. In ecological terms, we can expect to career through the decades ahead like a brakeless truck on a mountain road. Fires as powerful as the Las Conchas may become commonplace but perhaps not so much in the Jemez Mountains, whose storehouse of long-accumulated fuels has partly been emptied. The crosshairs of change seem momentarily to have shifted to California, but other parts of New Mexico and throughout the West will soon enough have their moment of fame, especially wherever older, over-dense forests remain. Indeed, global research, some of it led by Craig Allen, shows that many forests throughout the planet are in decline, afflicted by fire, insects, altered moisture regimes, and all the other ills a changing climate can produce. As the transformations that have so startlingly begun in the Jemez Mountains continue to spread from region to region, we'll have lots of things to concern us. The fate of the Jemez may ultimately be the least of our worries.

FIREGHOSTS

FOREST**ELEGY**

Philip Metcalf

To me photography is an art of observation . . .
I've found it has little to do with the things you see
and everything to do with the way you see them.
–ELLIOTT ERWITT

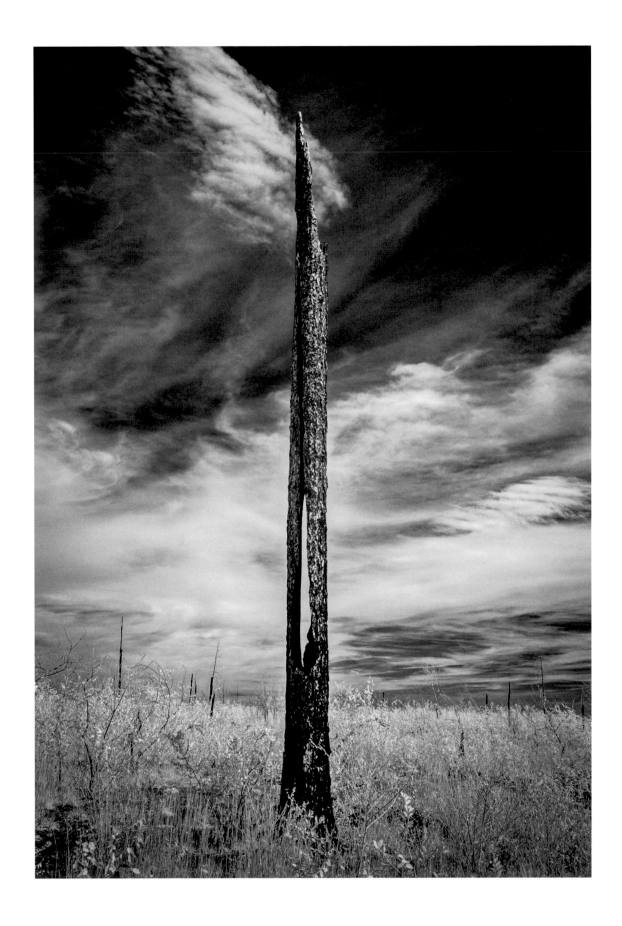

23

SANTA FE NATIONAL FOREST NEAR FOREST ROAD 289

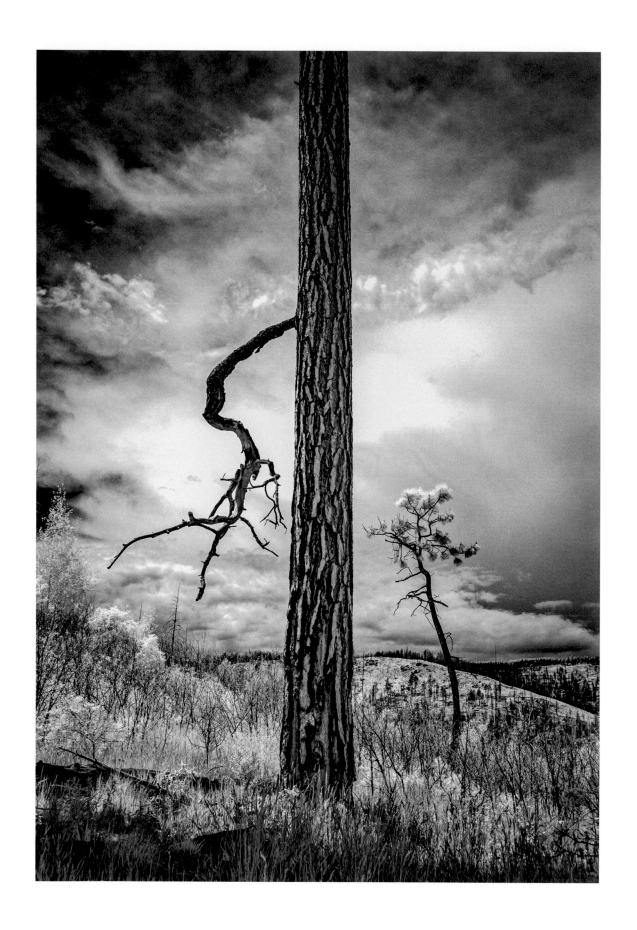

SANTA FE NATIONAL FOREST

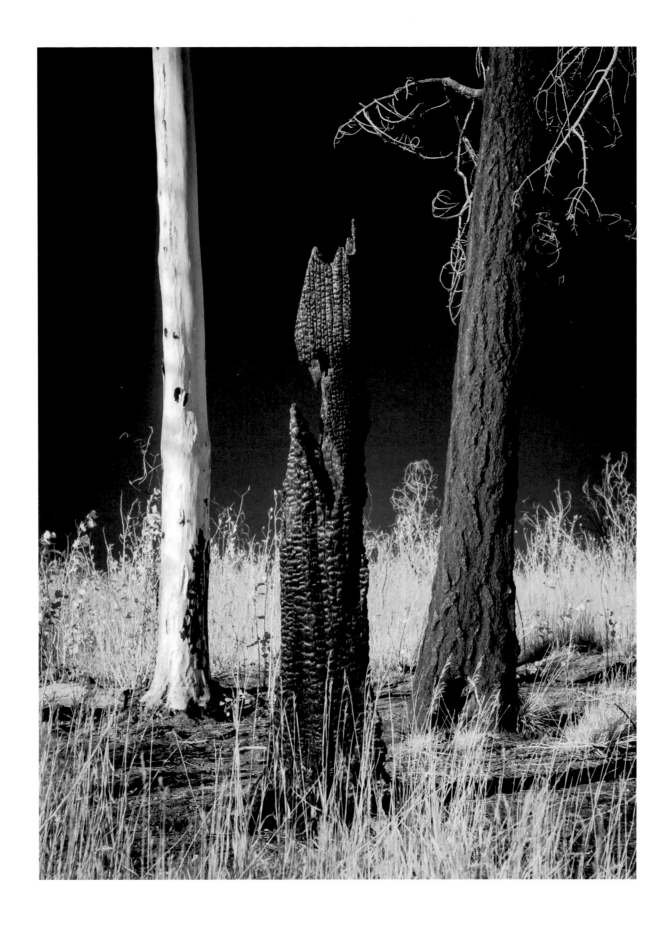

25

SANTA FE NATIONAL FOREST BETWEEN ALAMO AND CAPULIN CANYONS

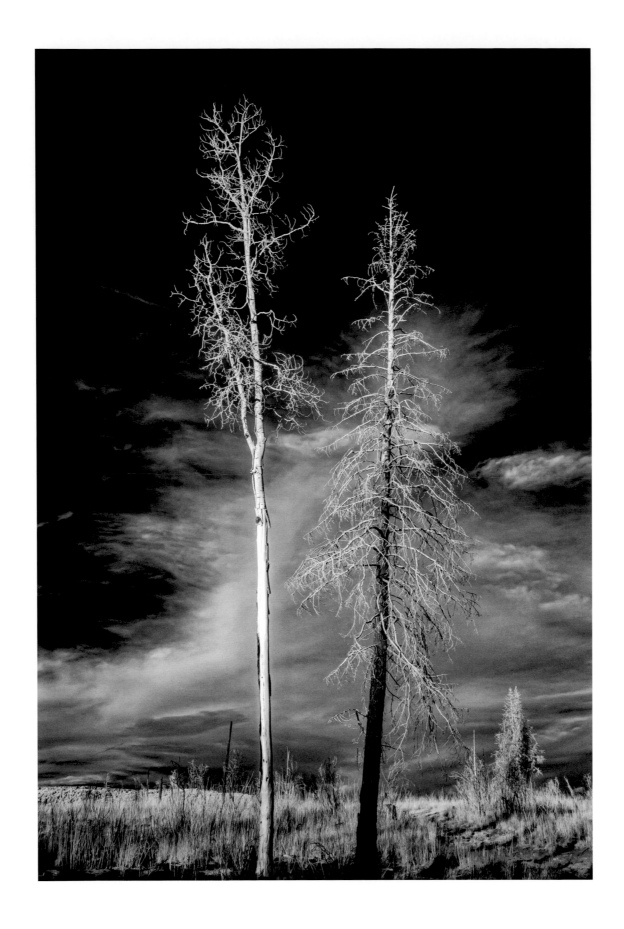

26

EIGHTEEN MONTHS AFTER THE LAS CONCHAS FIRE

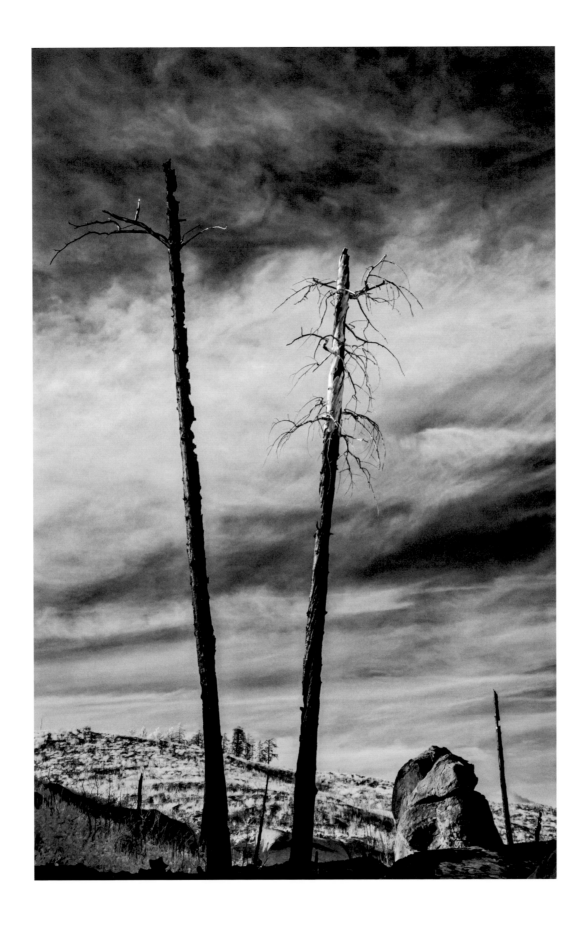

27

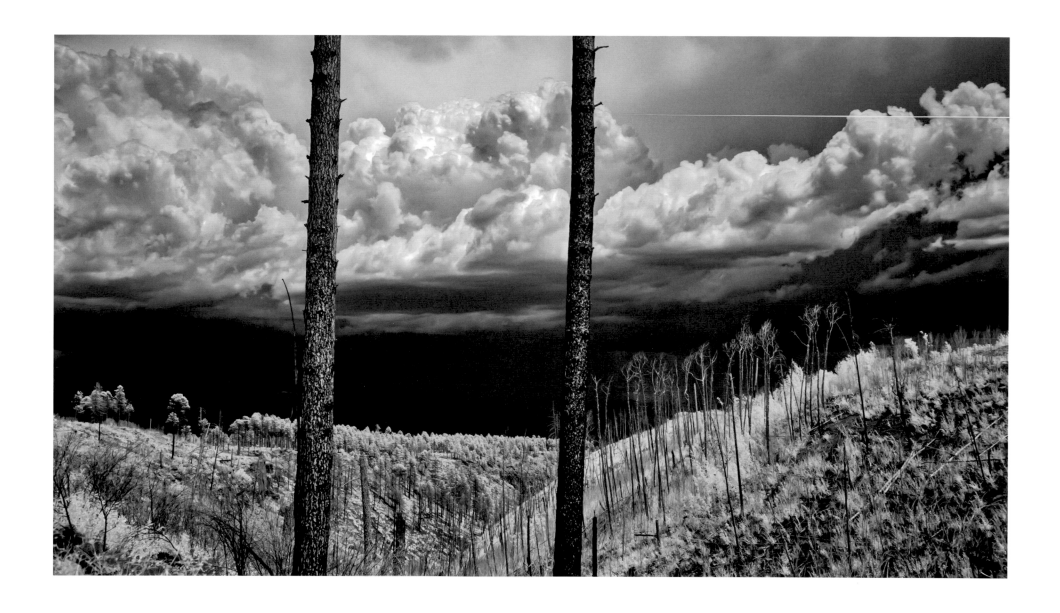

NEAR NATIONAL FOREST ROAD 286, EAST OF PINES CANYON

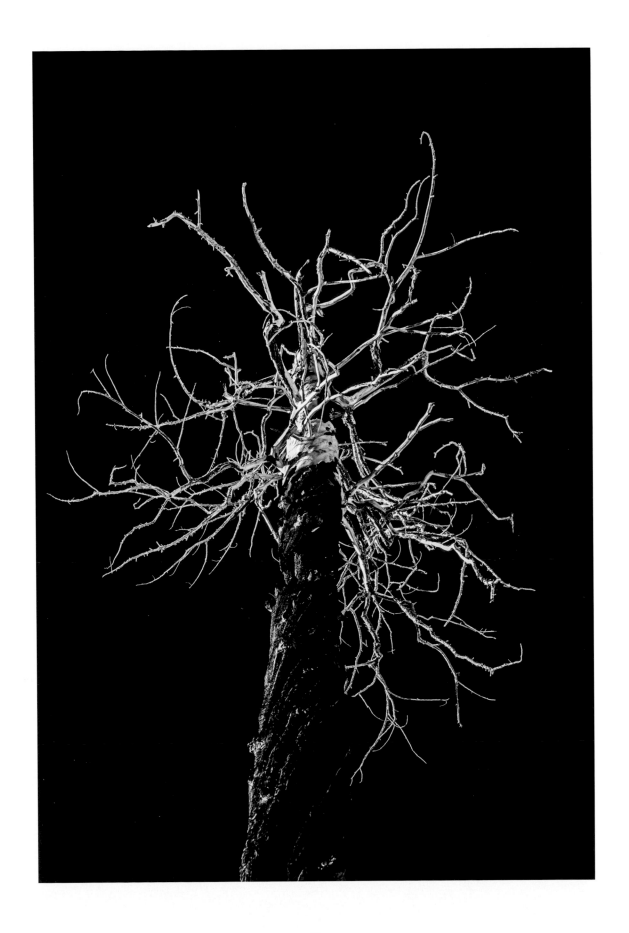

IN CAPULIN CANYON

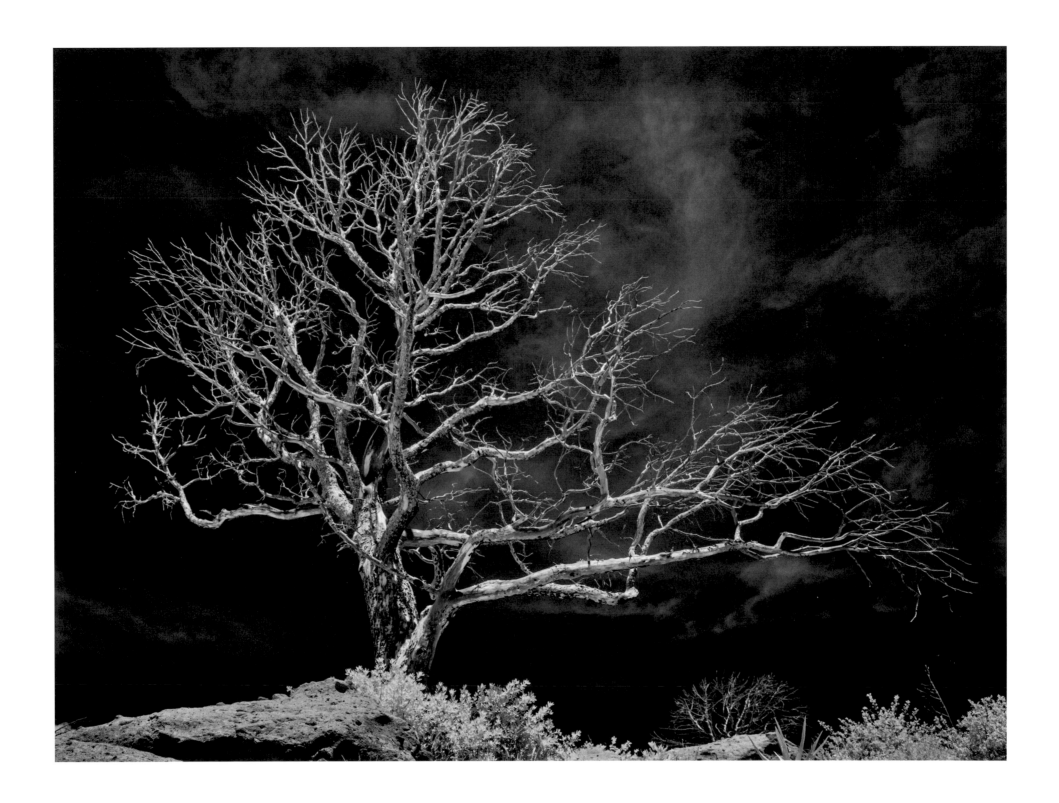

33

NEAR COCHITI CANYON OVERLOOK

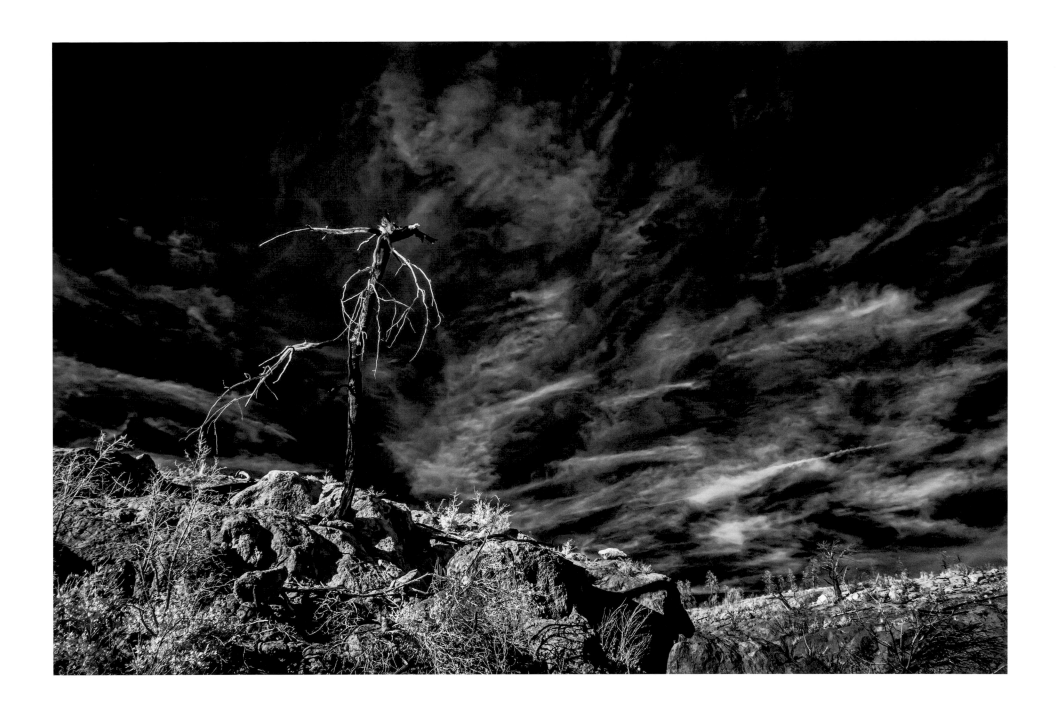

WEST OF SANCHEZ CANYON

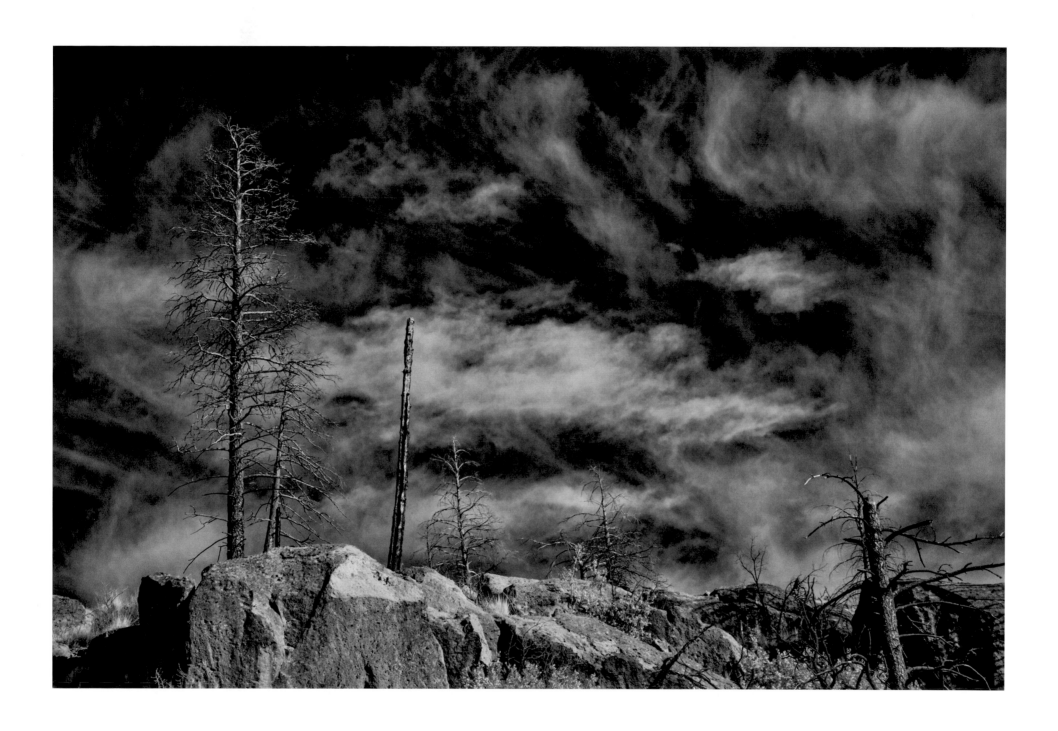

IN CAPULIN CANYON

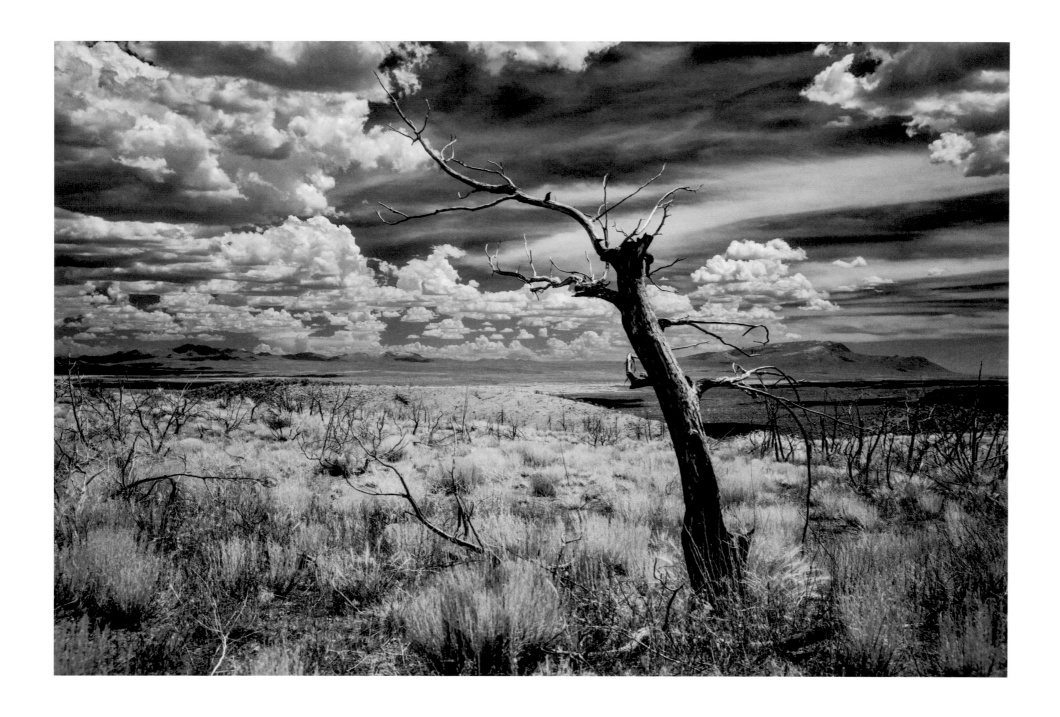

TURKEY SPRINGS TRAIL

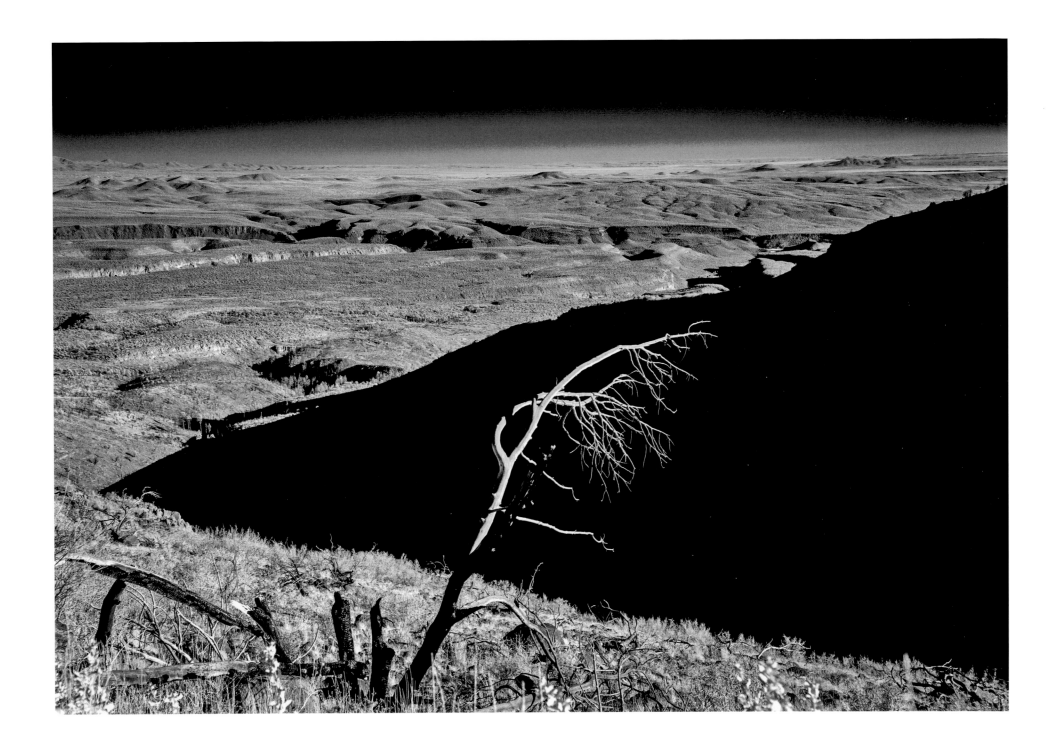

41

IN THE DOME WILDERNESS LOOKING TOWARD THE SANGRE DE CRISTO MOUNTAINS

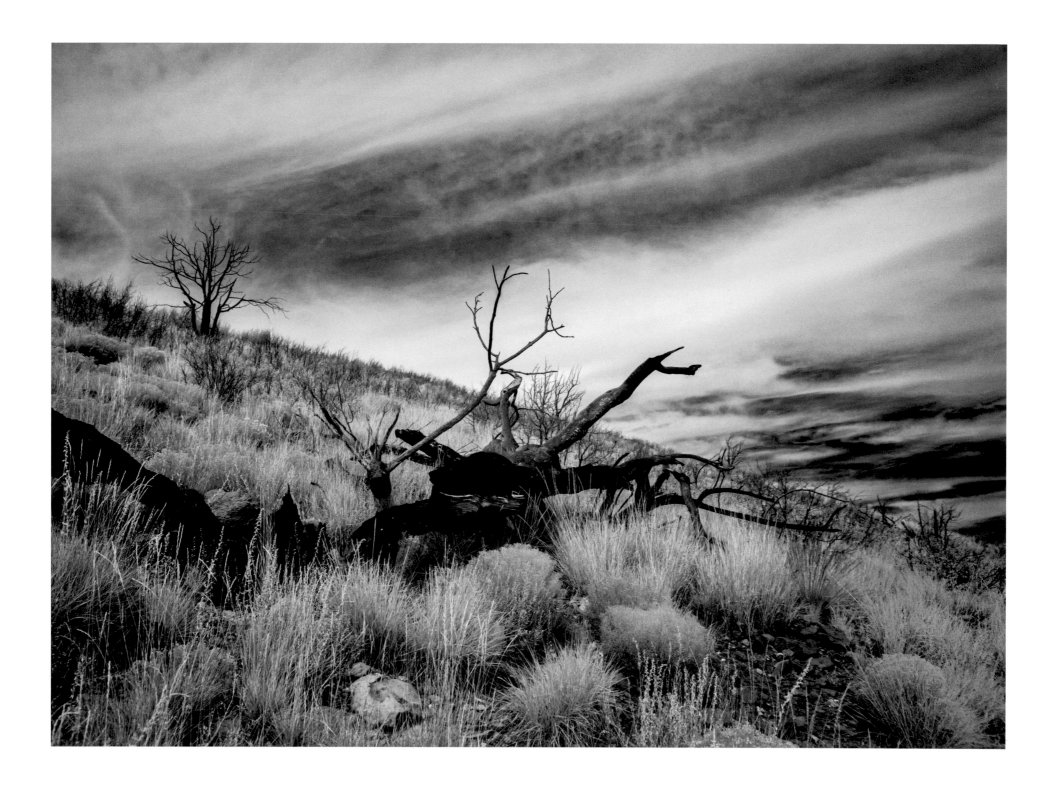

43

THE DOME WILDERNESS, NEAR BOUNDARY PEAK

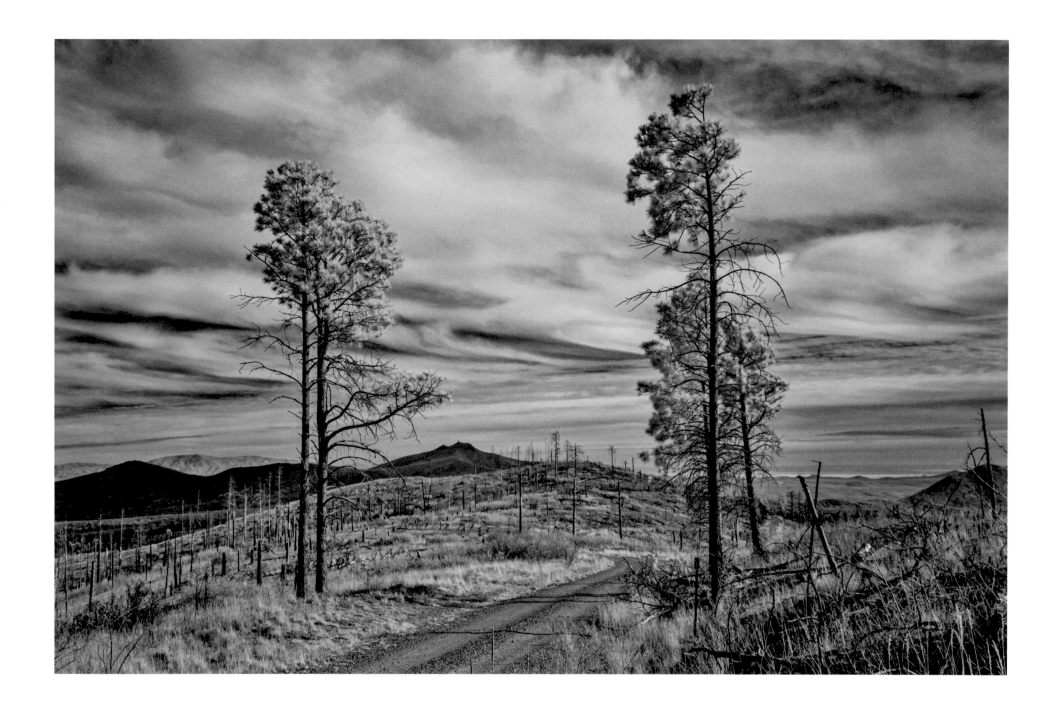

45

NEAR FOREST ROAD 289

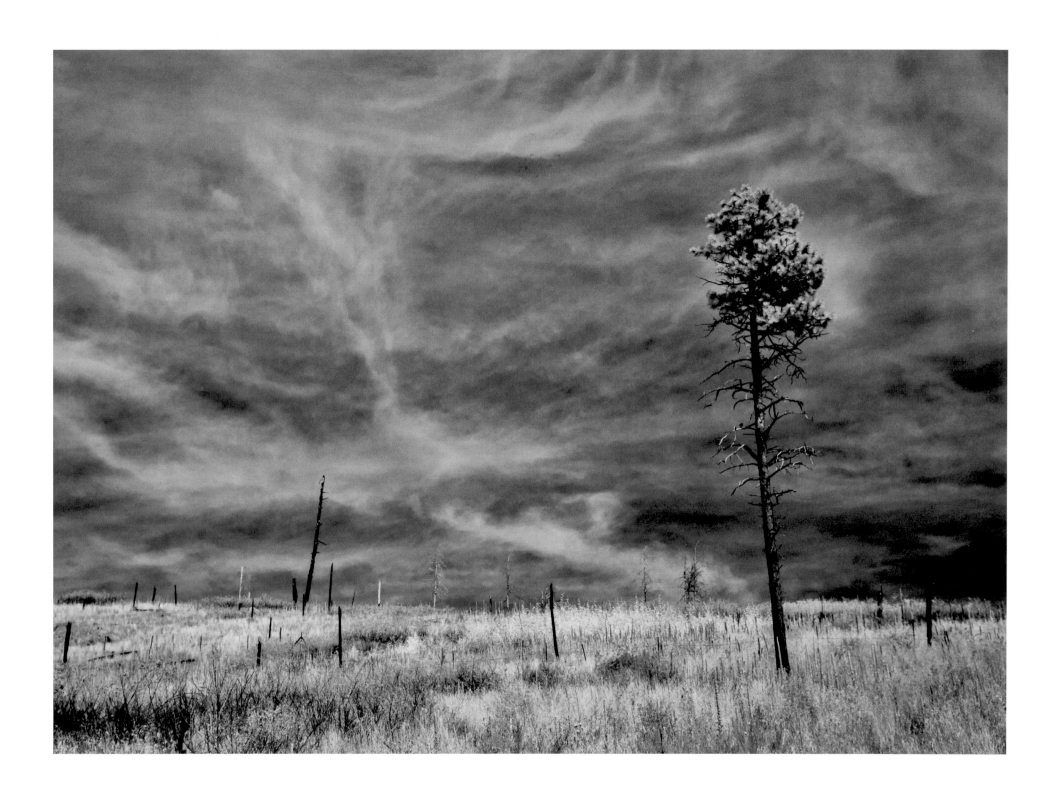

47
NEAR CAPULIN CANYON
Following spread: ST. PETER'S DOME

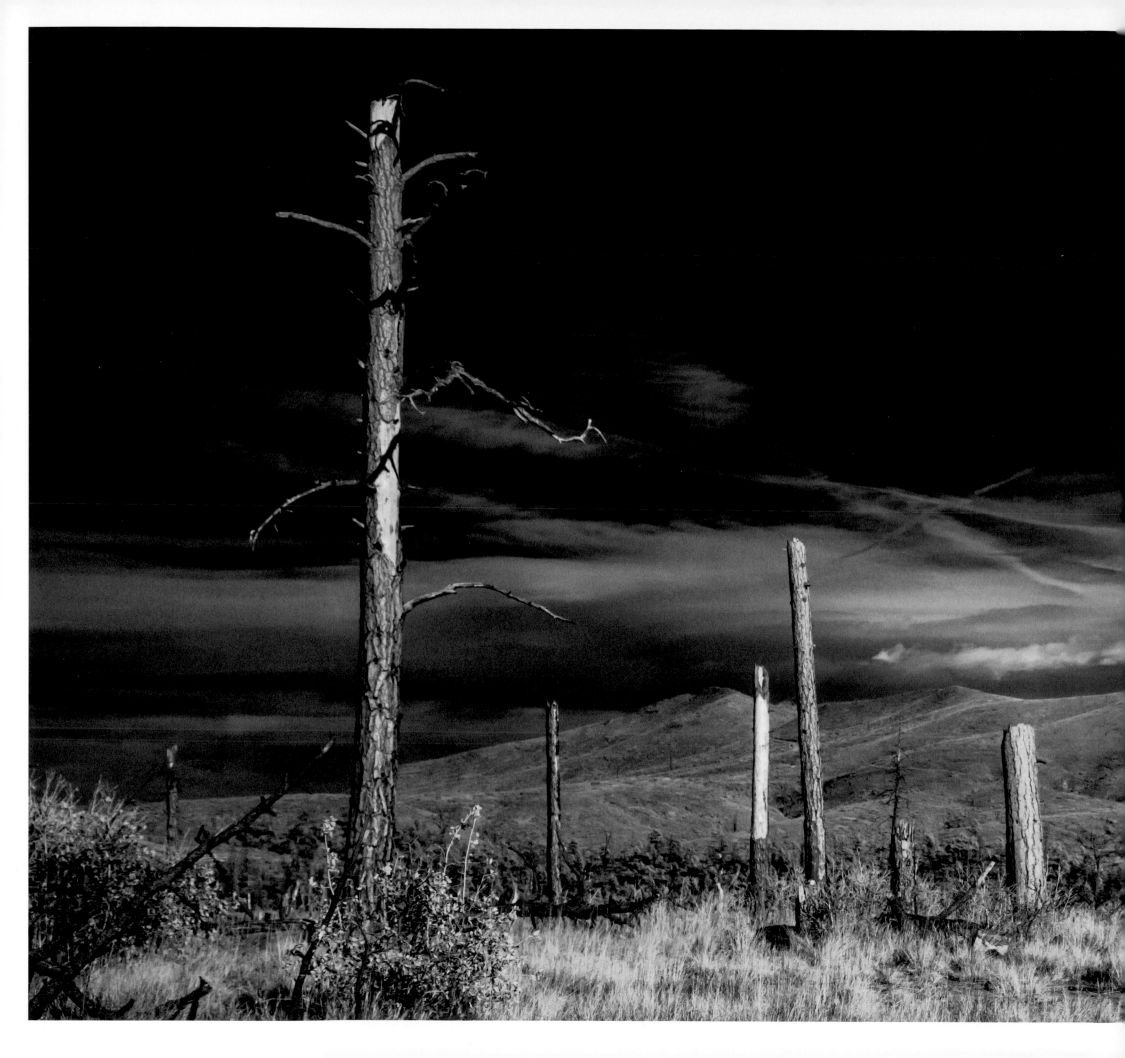

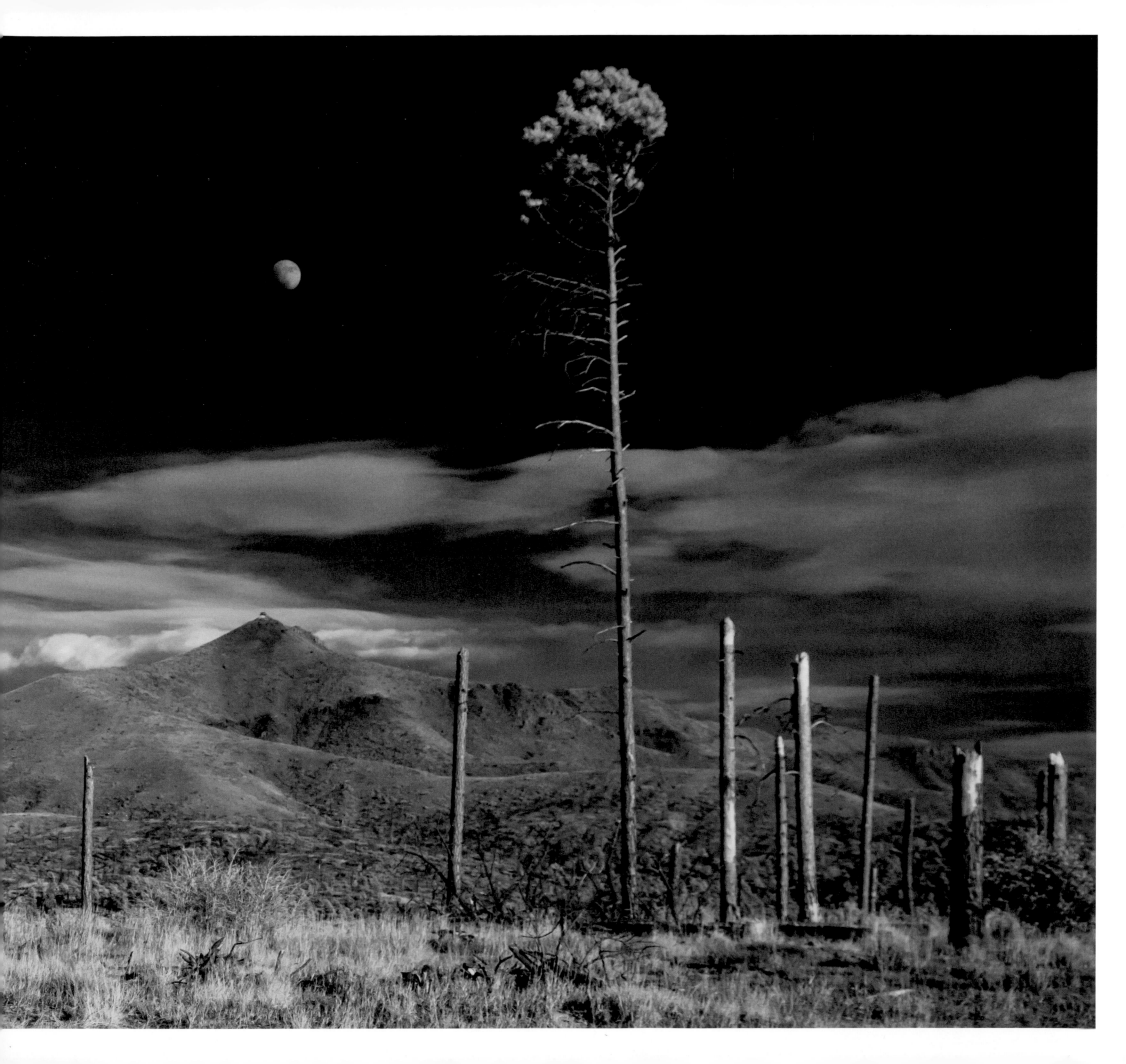

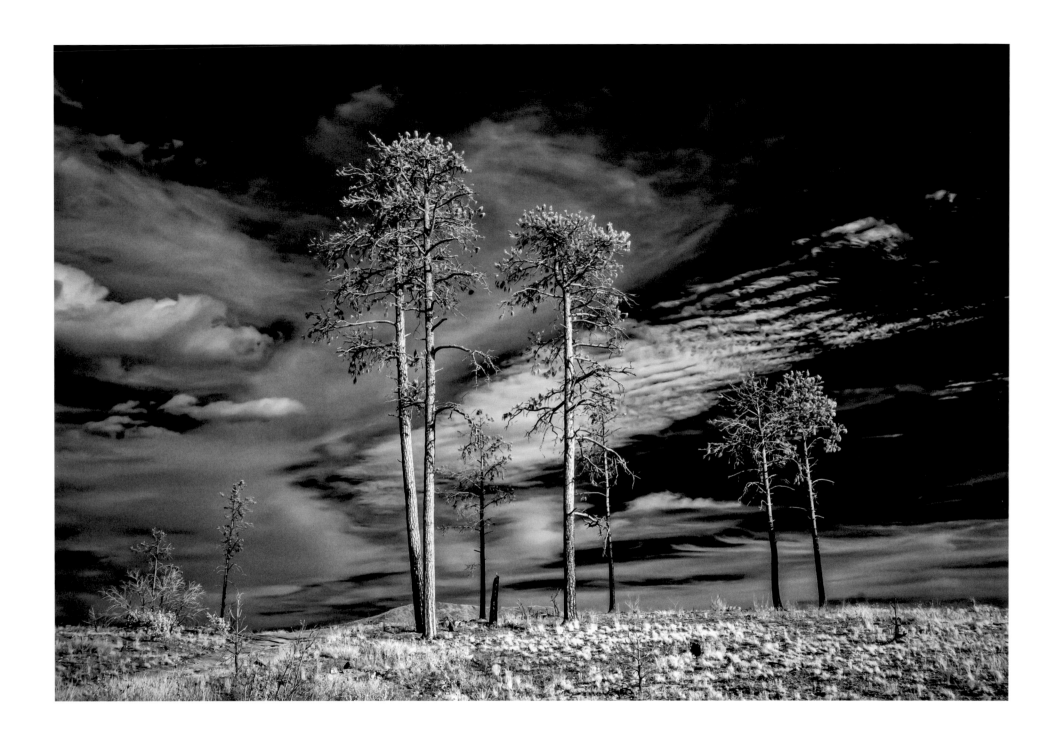

51

NEAR CERRO BALITAS

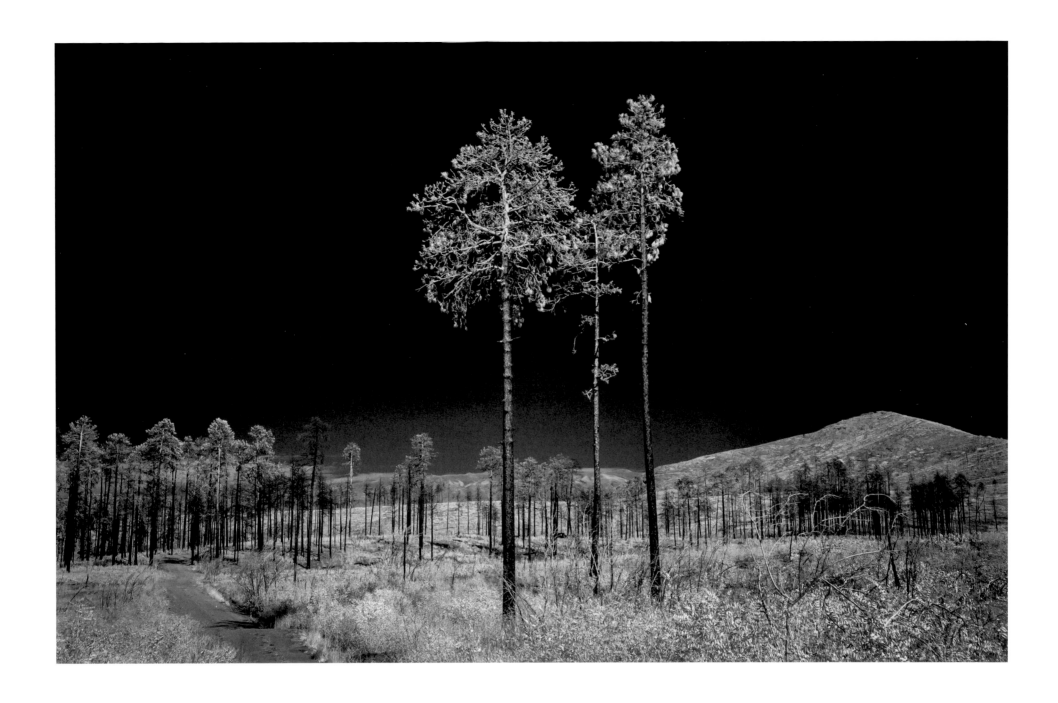

THE DOME WILDERNESS

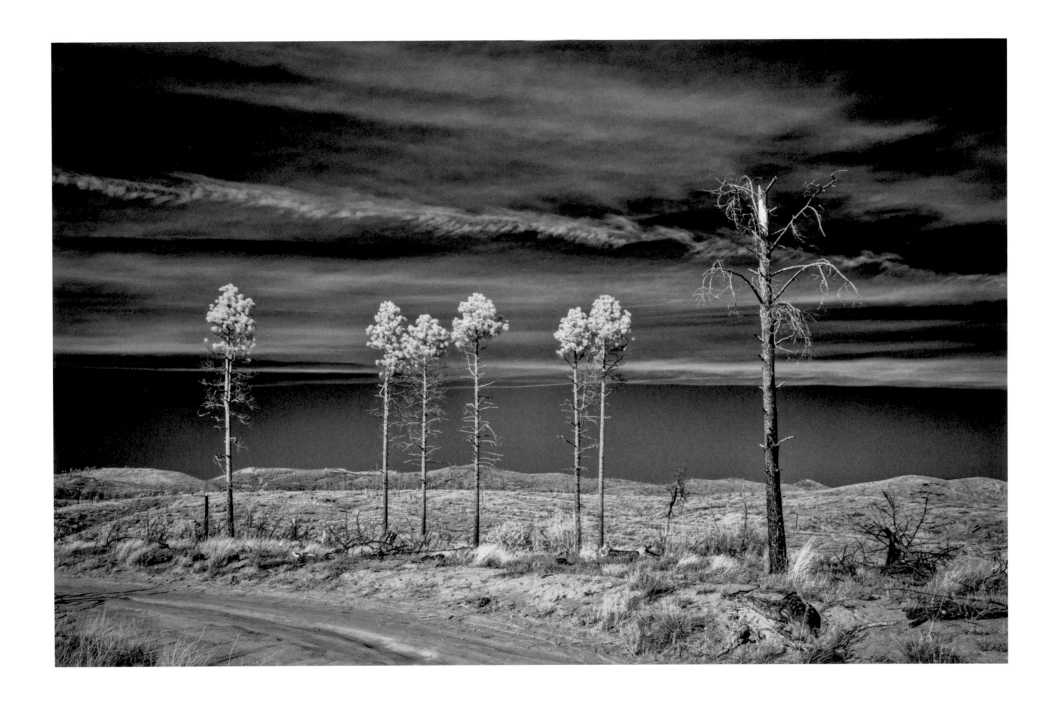

55

ALONG FOREST ROAD 289

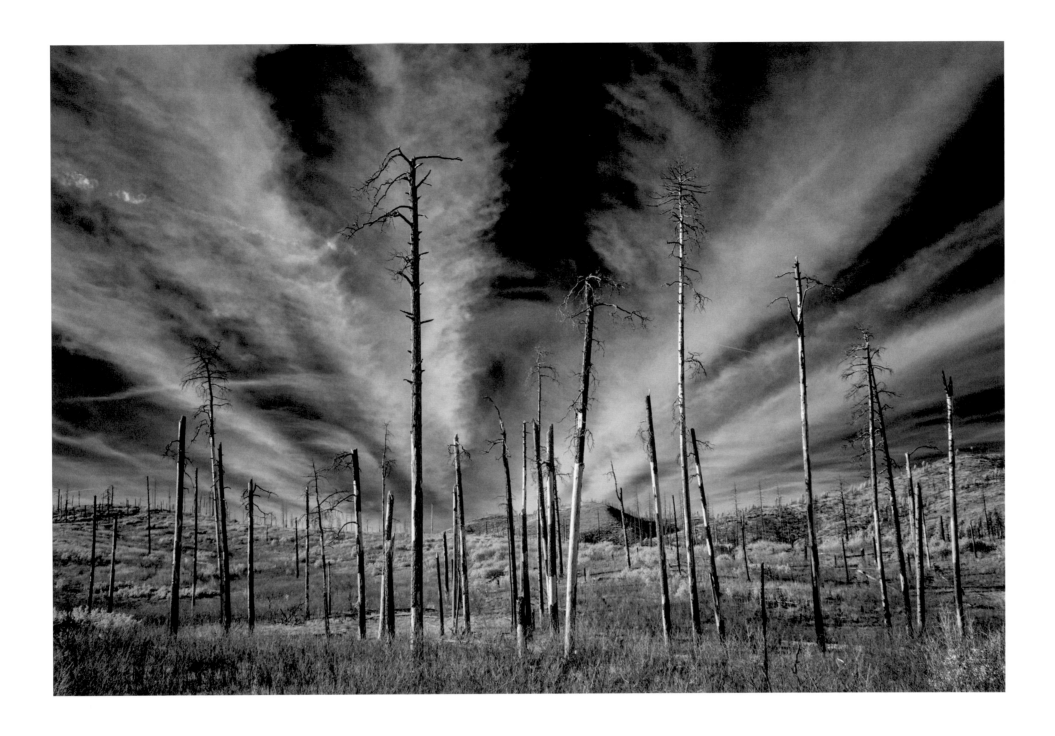

THE DOME WILDERNESS SEVEN YEARS AFTER THE LAS CONCHAS FIRE

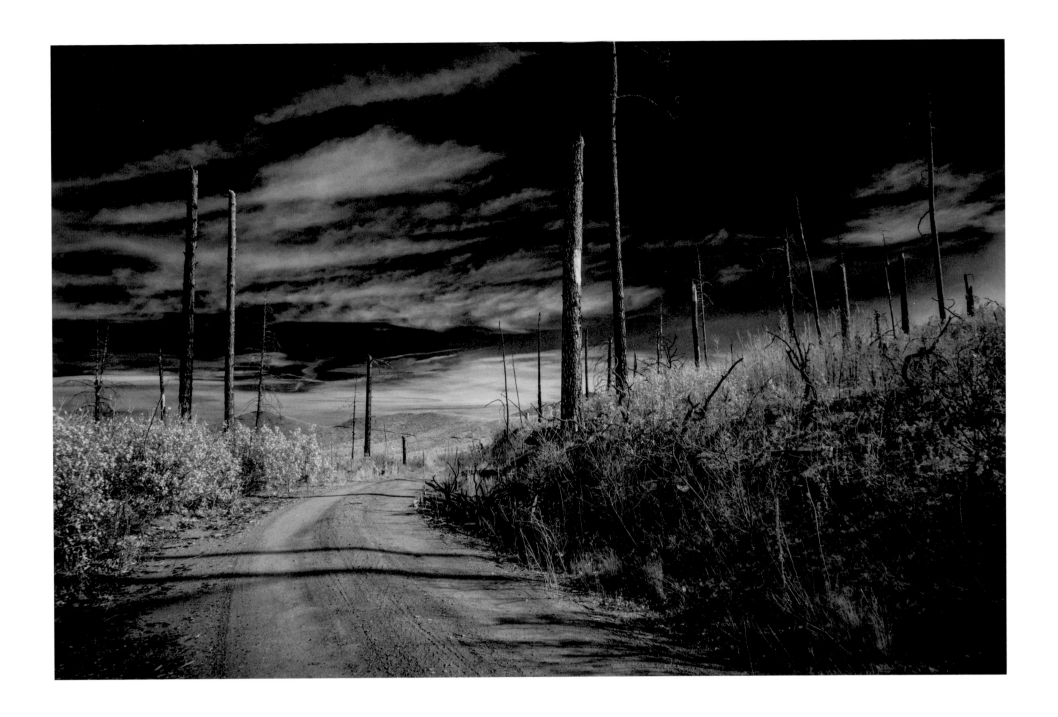

ST. PETER'S DOME ROAD

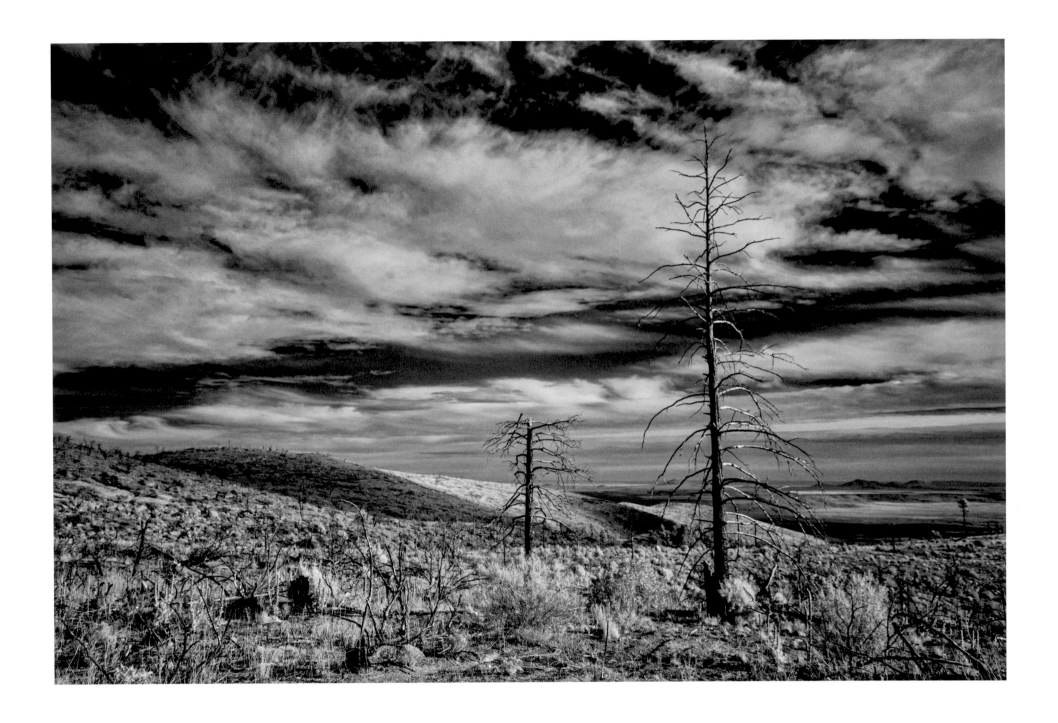

61

WINTER, SIX YEARS AFTER THE LAS CONCHAS FIRE
Following spread: SANTA FE NATIONAL FOREST

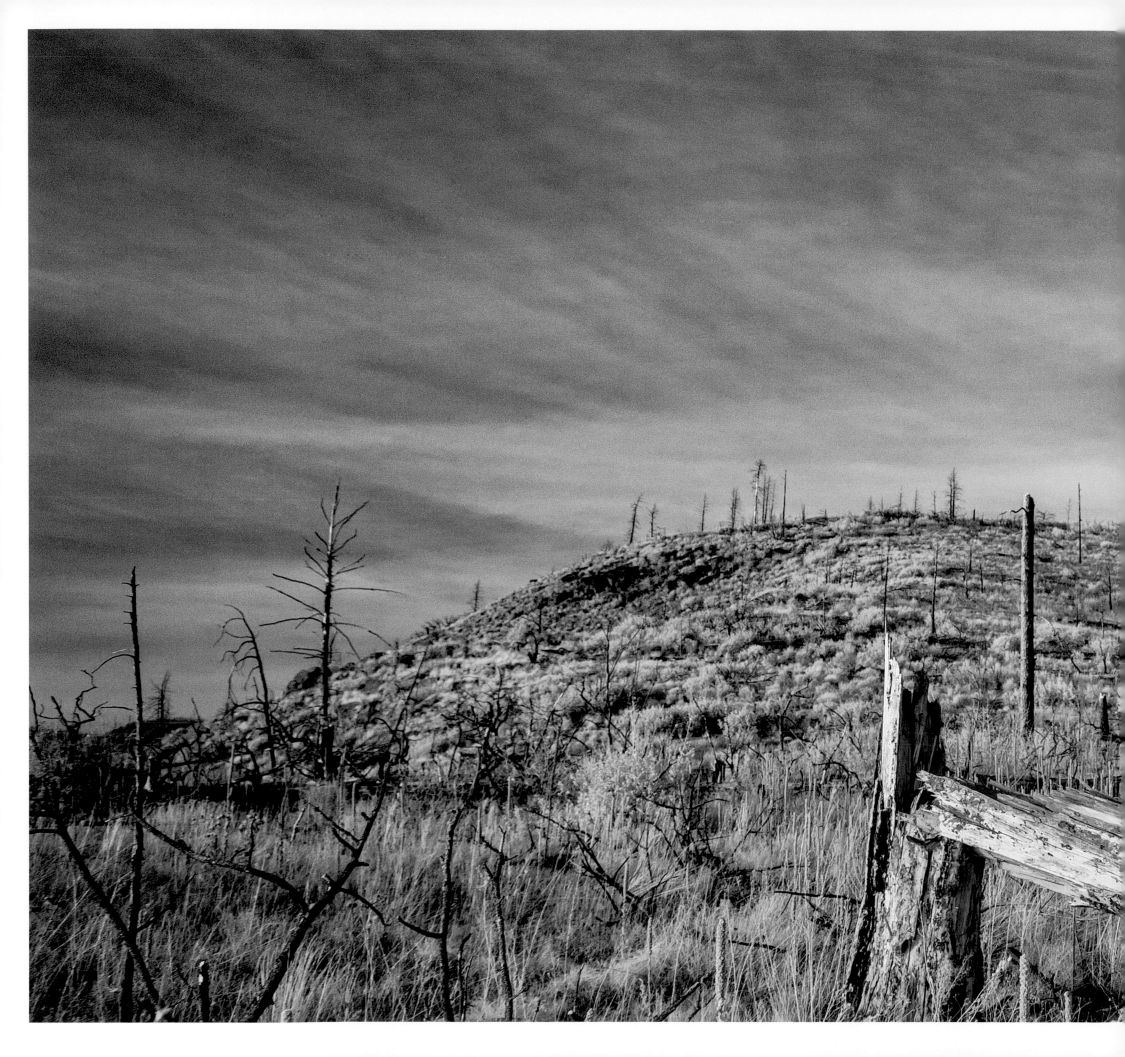

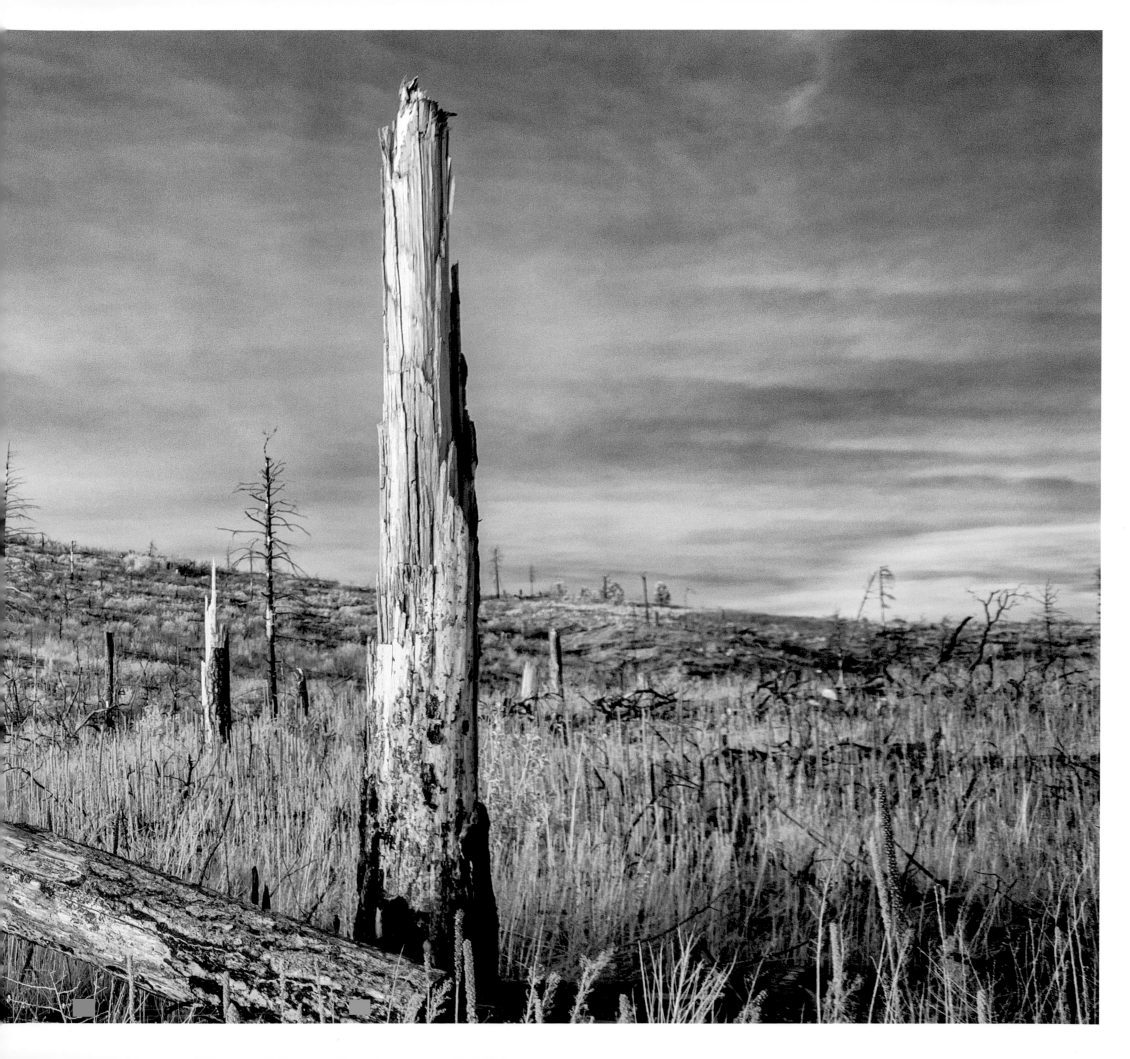

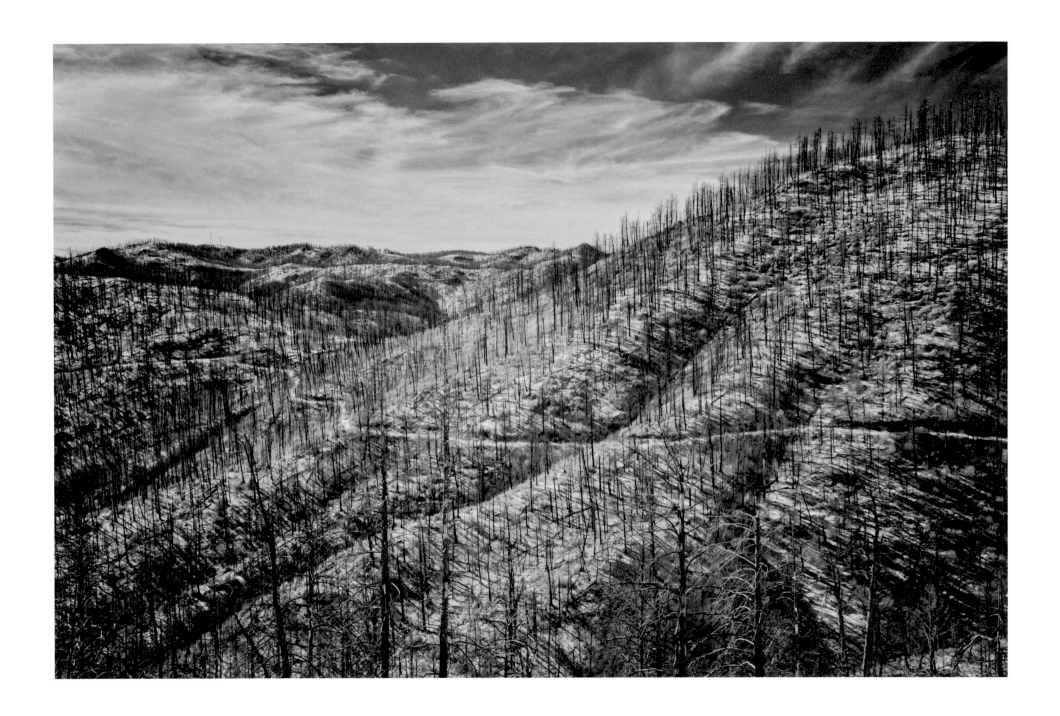

PRIVATE ROAD ON CRAGER RIDGE

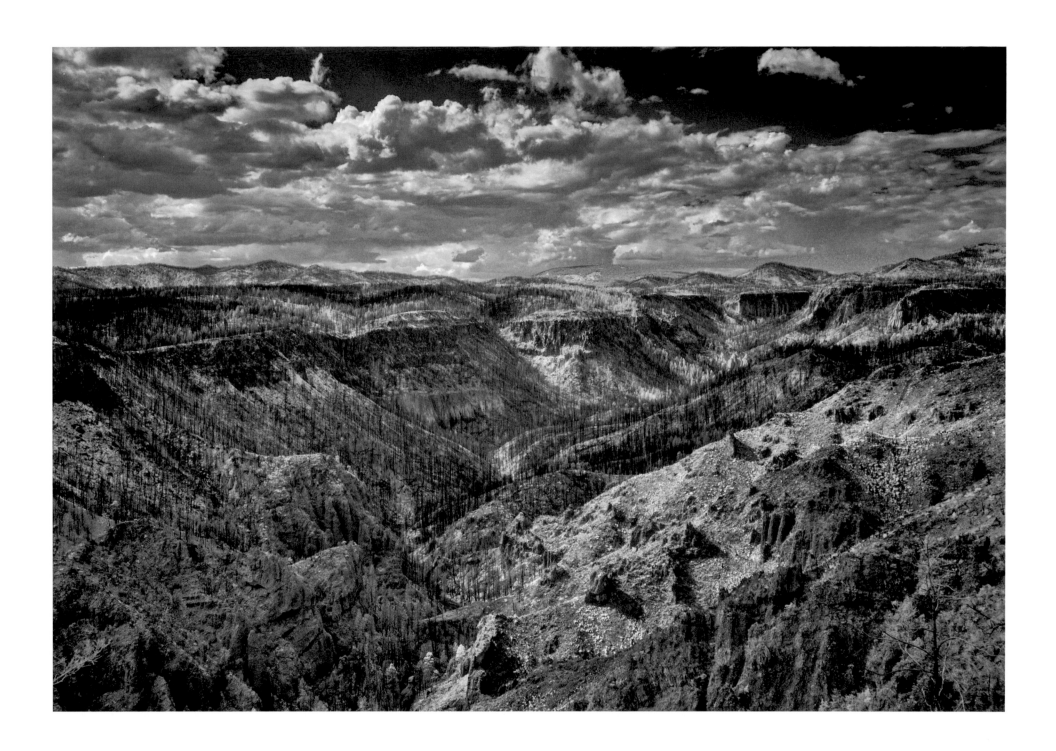

67
COCHITI CANYON

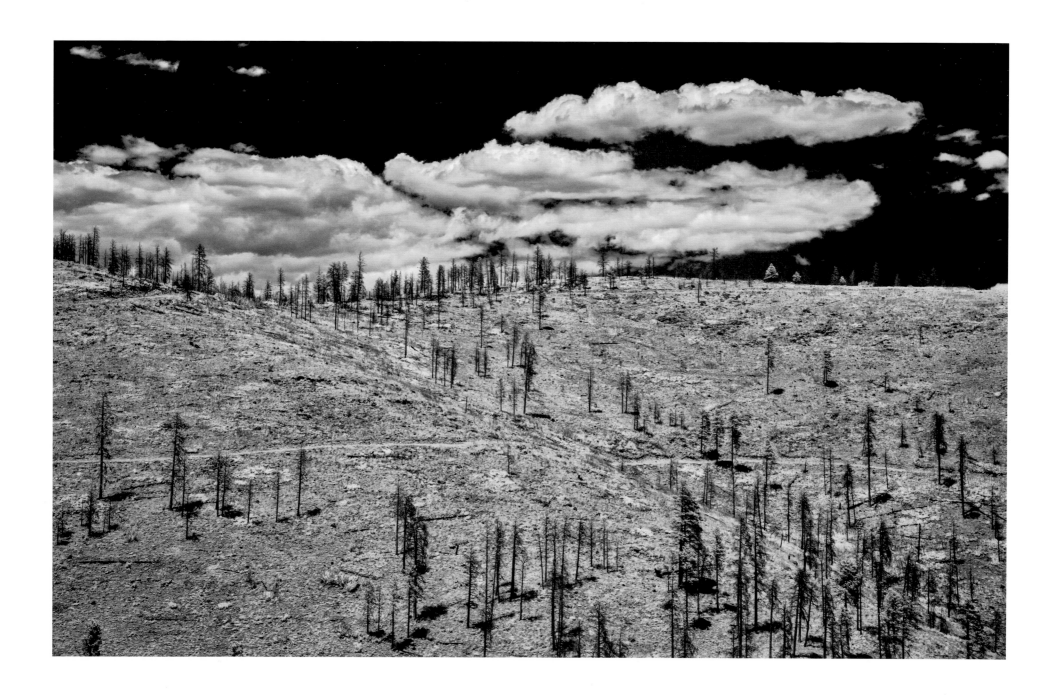

69

ABANDONED LOGGING ROAD

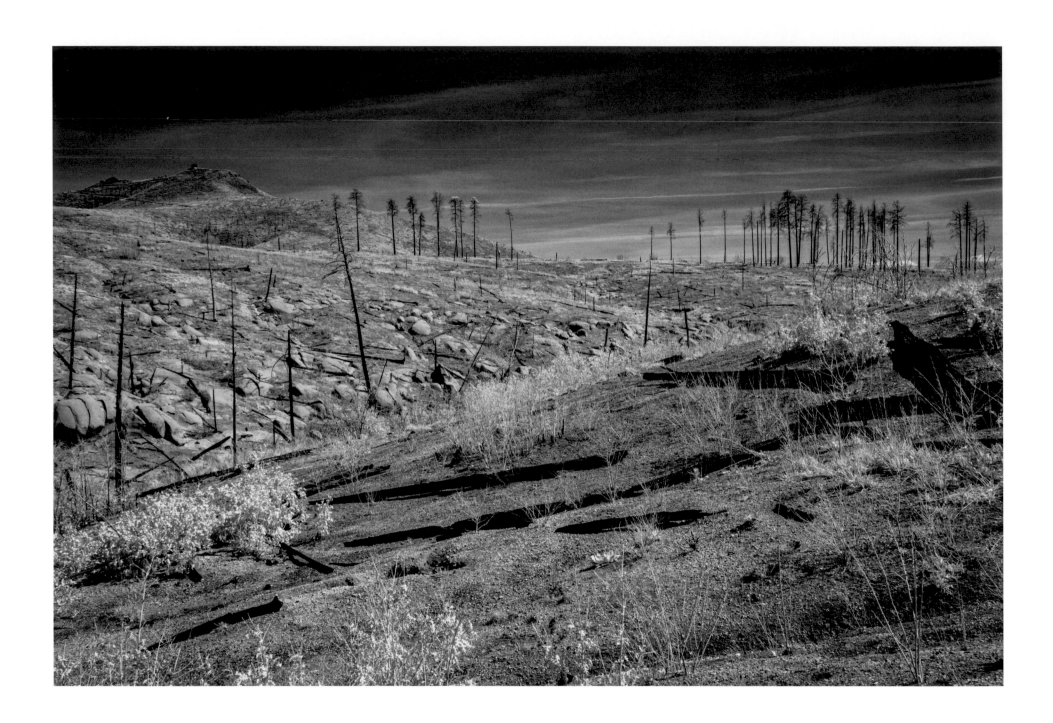

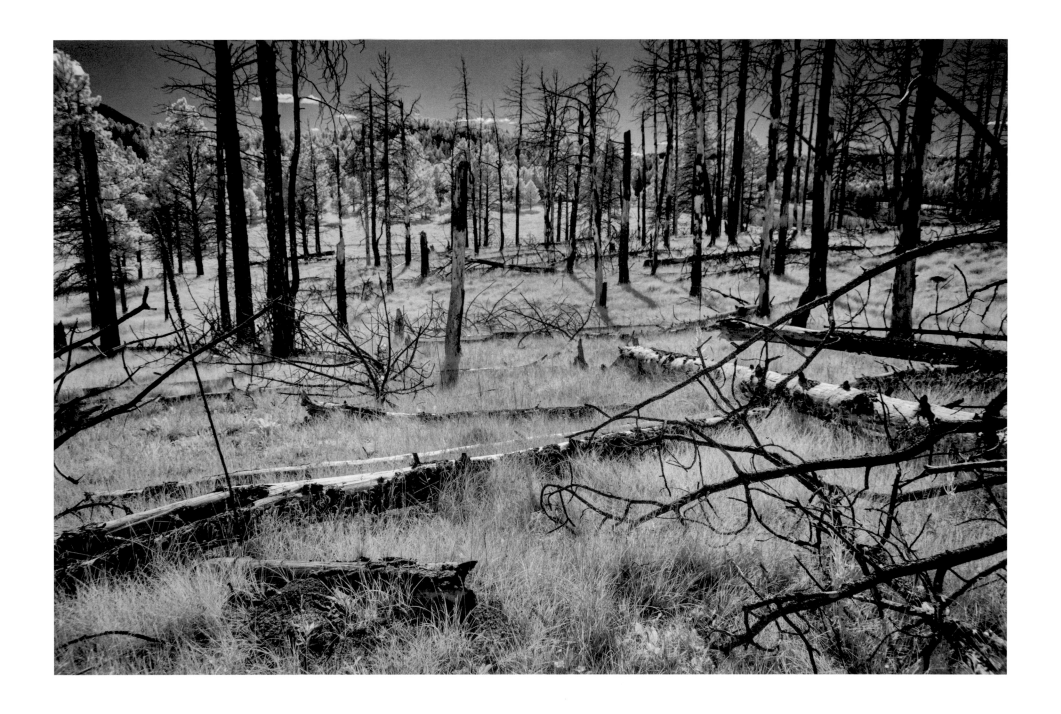

NORTHERN FIRE PERIMETER, VALLES CALDERA NATIONAL PRESERVE, BACK COUNTRY

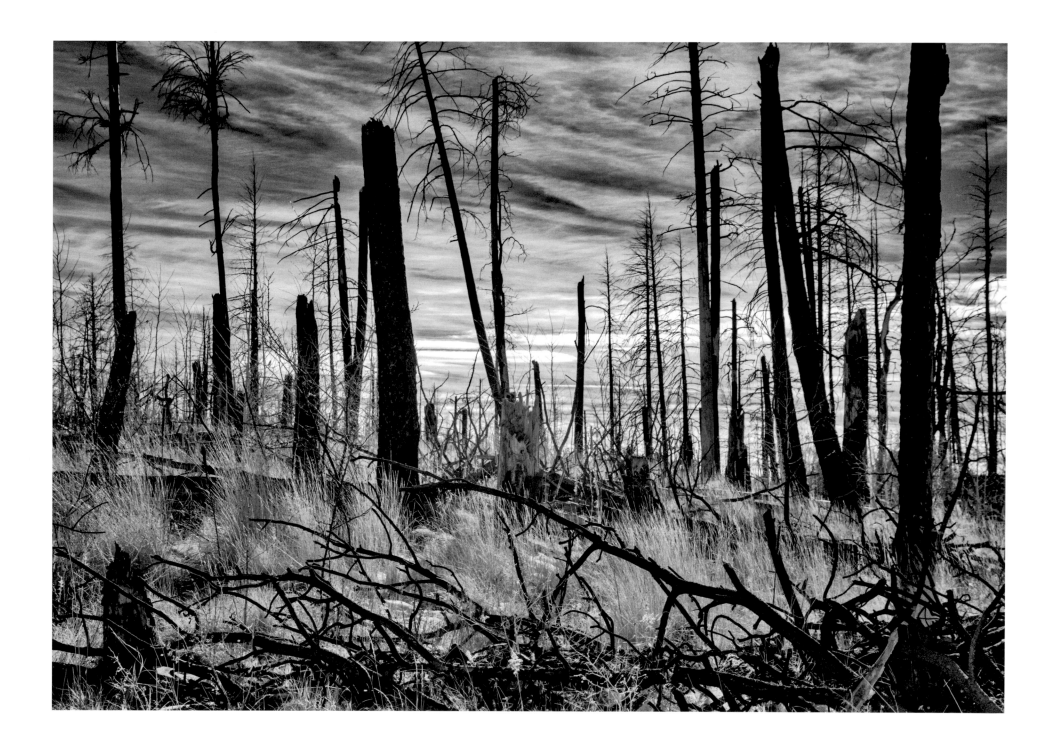

FIVE YEARS AFTER THE LAS CONCHAS FIRE

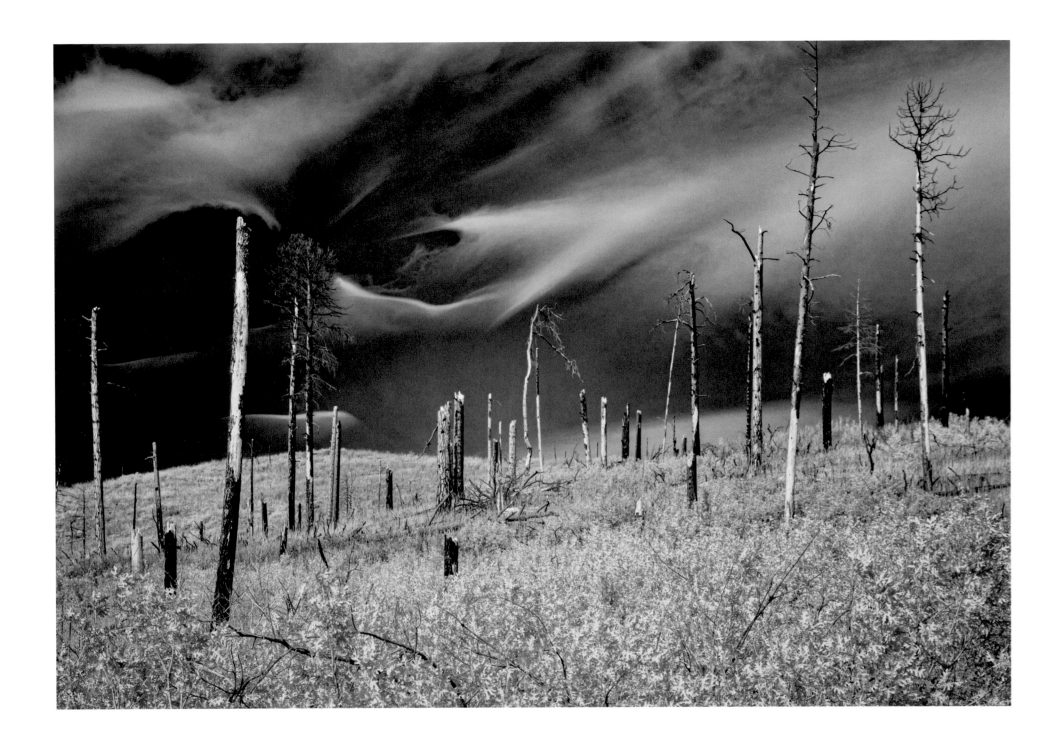

LOST PINES NEAR COCHITI CANYON

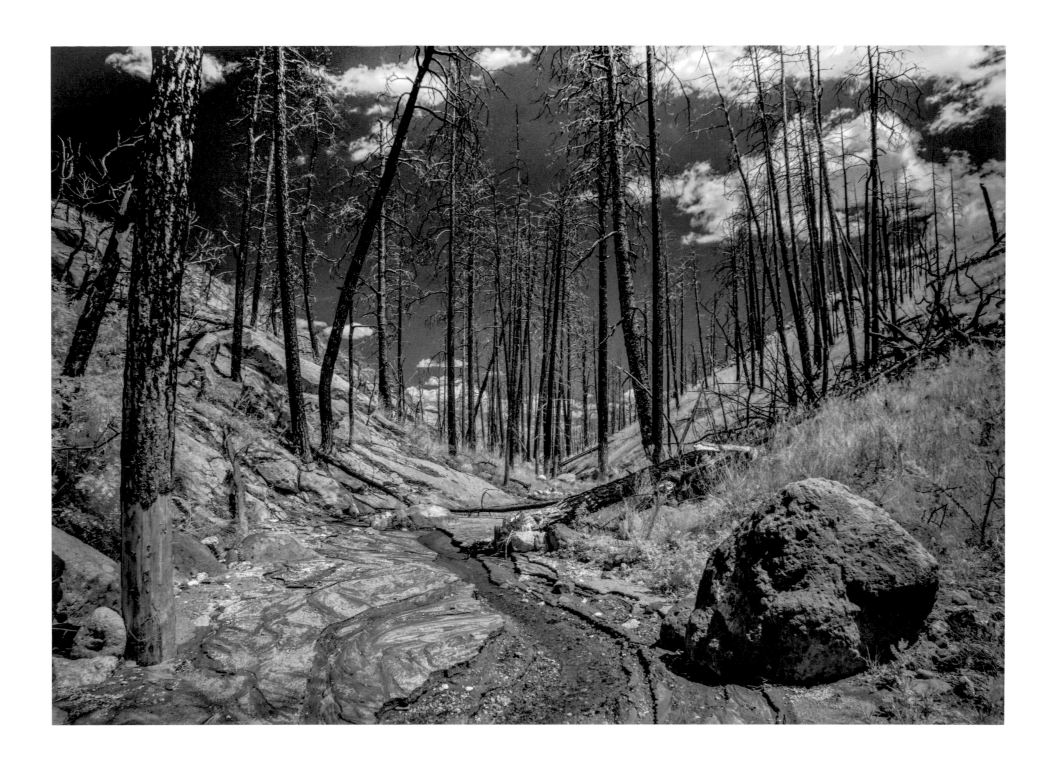

77

SANCHEZ CANYON

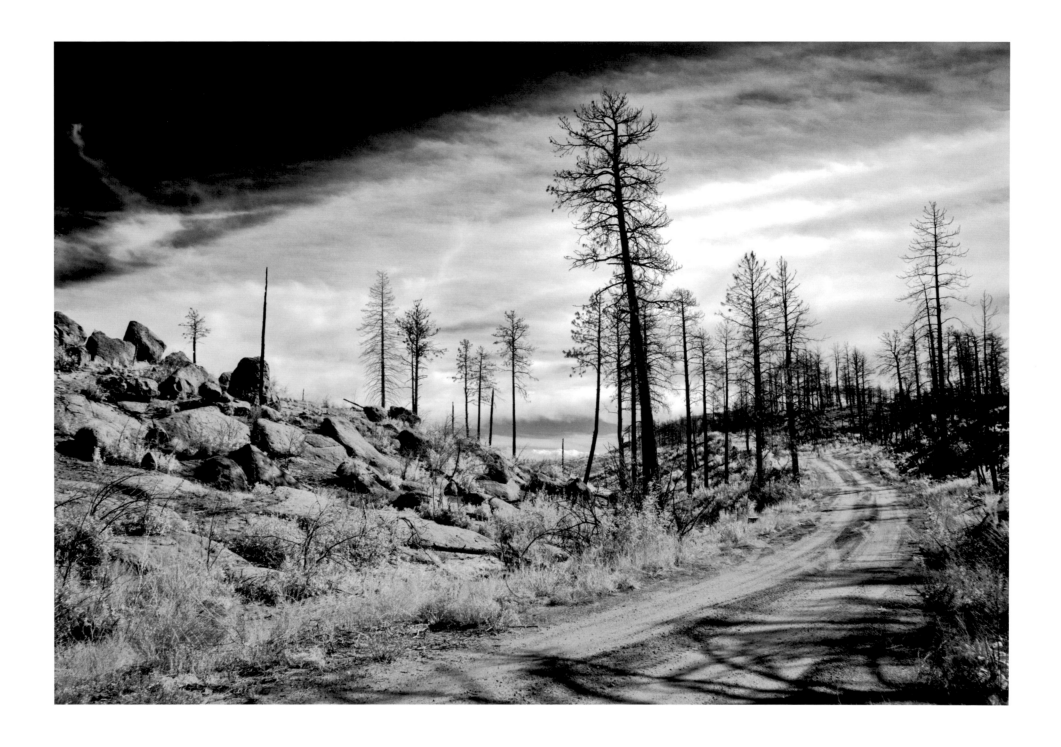

79

NATIONAL FOREST ROAD 289

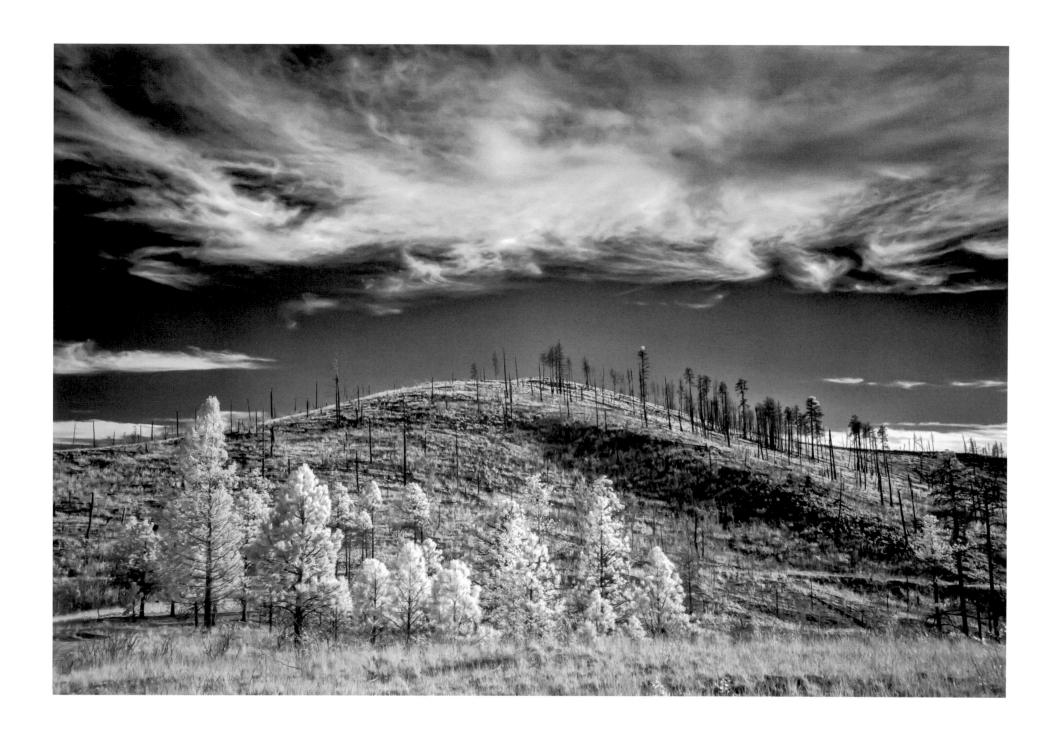

81
RABBIT HILL
Following spread: WINTER 2016

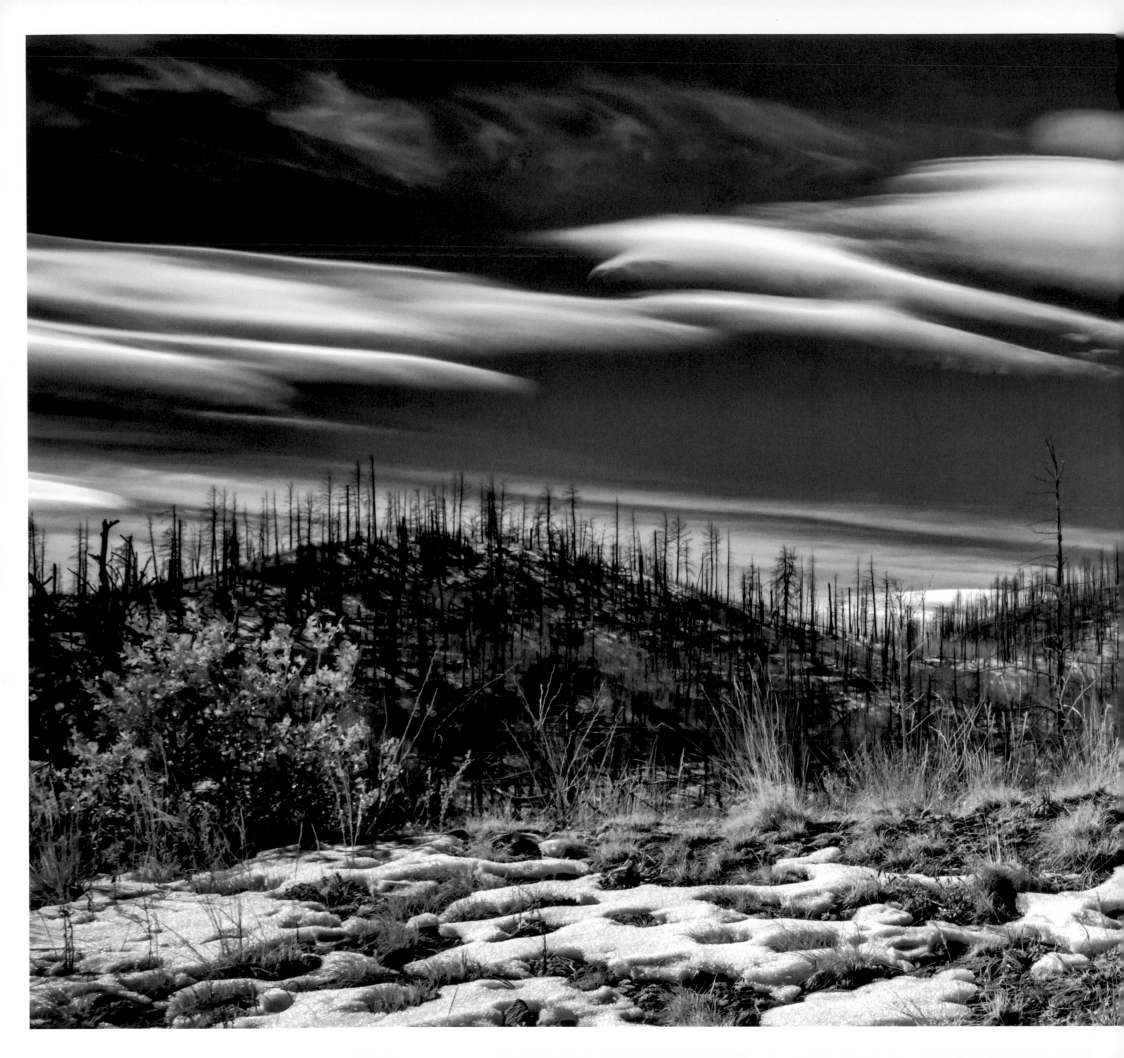

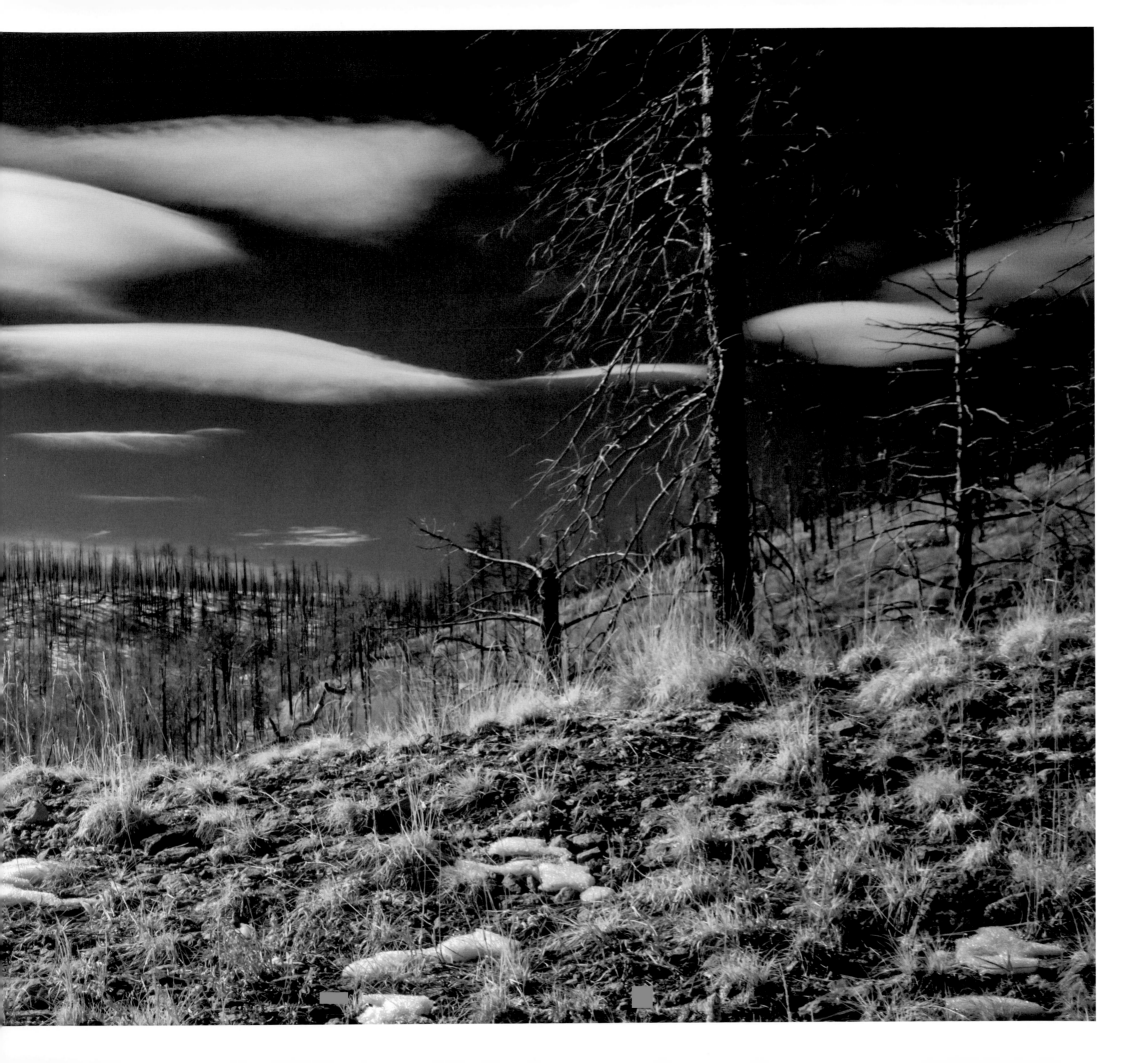

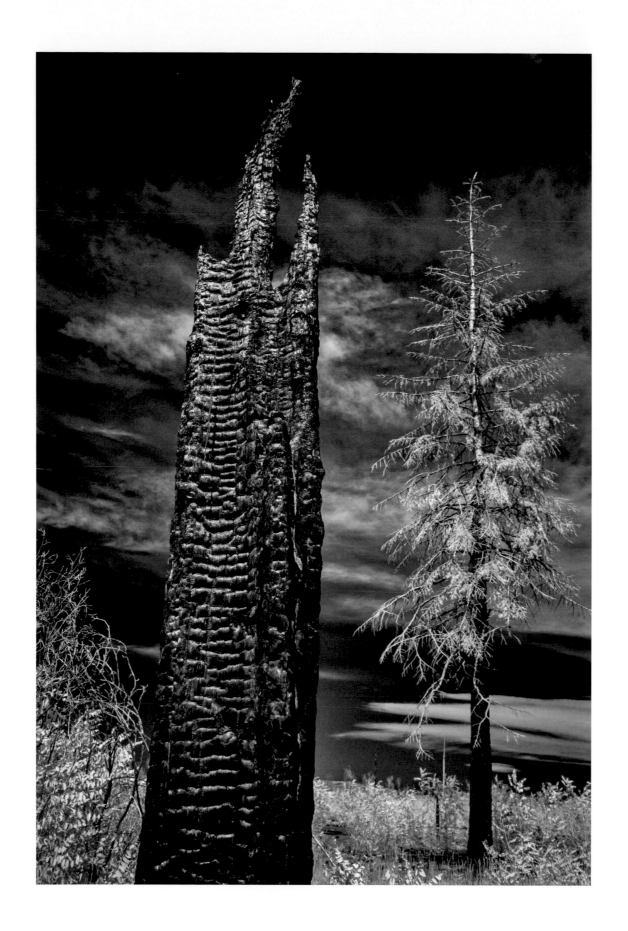

BURNED PONDEROSA PINES

A SHRUBBIER FUTURE
FOREST TRANSFORMATION IN THE EASTERN JEMEZ

Craig D. Allen

THE JEMEZ MOUNTAINS are the most visually distinctive feature on any aerial map of northern New Mexico, immediately recognizable by the striking, million-year-old Valles Caldera at the heart of this volcanic sky island. Grasslands and wet meadows mantle the low-lying ancient lakebeds of the caldera basin, punctuated by forested mountain domes and rimming sierras that reach more than 11,000 feet on the summits of Redondo Peak and Tschicoma Peak, mountains sacred to many Puebloan peoples of New Mexico. Plateaus, canyons, and mesas radiate from the caldera's core, and the entire Jemez area is encircled by river valleys, including the Rio Grande to the east.

Cool and wet mountain forests dominate the high-elevation portions of the Jemez, similar to Rocky Mountain forests that extend north from here into Canada, with associated plant species, including Engelmann spruce, subalpine fir, and bog birch. In contrast, the lower slopes and valleys of the southern Jemez feature drier forests and woodlands populated with drought-adapted species ranging from alligator-bark junipers and Sonoran live oaks to black gramma grasses.

In the southeast plateau of the Jemez arise the low volcanic peaks of the San Miguel Mountains, including Saint Peter's Dome, which contains the upland headwaters of Alamo, Capulin, and Sanchez Canyons adjoining the western margin of Bandelier National Monument (established in 1916, the year the National Park Service was founded). Prior to recent fires, ponderosa pine forests dominated most of the Dome

area landscape, which is the focus of many of the striking photographs in this book.

Lately, these long-standing vegetation patterns have been in rapid transition. At about 1:00 p.m. on June 26, 2011, strong winds felled a ninety-year-old aspen stem with a bit of heart rot onto a small power line in the south-central Jemez, sparking what came to be known as the Las Conchas Fire. Ignited during extremely dry, warm, and windy conditions, this fire burned an astounding 43,624 acres within the first fourteen hours, mostly at tree-killing severities. Over the following weeks, the Las Conchas Fire burned across 248 square miles, converting extensive areas of green forest, woodland, and shrubland into blackened stands of charred snags. This monster fire brought profoundly transformative landscape change to the eastern Jemez, compellingly illustrated in this book by Philip Metcalf's and Patricia Galagan's photographs.

Diverse human communities inhabit the Jemez landscape, including some of the oldest human settlements in North America. Indigenous Puebloan tribes—including the Jemez, Santa Clara, Cochiti, and San Ildefonso—have been present in the area for more than 1,000 years. Hispanic villages such as Santa Cruz date back hundreds of years, and towns such as Los Alamos, Pojoaque, and White Rock have housed people connected with Los Alamos National Laboratory (established in 1943) and Bandelier National Monument for several generations. All of these communities have deep relationships with local forest lands and

their fire histories. Yet the extreme behavior and effects of the Las Conchas Fire (and post-fire floods and debris flows) shocked everyone, as they ratcheted up the pace and scale of landscape change in the Jemez beyond anything in living memories or older oral traditions.

Despite the general initial perceptions of this as a "catastrophic" fire, it is important to ask: What does the Las Conchas Fire look like in the context of scientific knowledge of landscape change over long time periods? How unusual was the Las Conchas Fire and its widespread impact on the landscape? Do the photographs in this book depict a unique moment in Jemez fire history?

I've been exploring the Jemez landscape for almost four decades, first as a graduate student doing field research on the long-term changes in the forests and grasslands of the Jemez and since as a "place-based" research ecologist for the U.S. Geological Survey New Mexico Landscapes Field Station at Bandelier National Monument. It has been fulfilling to sink roots here and to make my career observing and documenting the shifting patterns and processes of the Jemez landscape. Through time I've learned how to weave together disparate threads of information to understand better the inter-linked human and non-human communities that comprise the living fabric of this wondrous place, explicitly considering landscape changes here. But even with this long career of local observation and study, the size and severity of the overnight transformations to deeply familiar forests wrought by the Las Conchas Fire were sufficiently extraordinary to be surprising and even disorienting for me.

DEEP-TIME RESEARCH FINDINGS

Many of my scientific colleagues and I have been working in the Jemez since the 1980s, using a variety of research methods to learn about variability and change in past and present climates, fire patterns, land uses, and forest conditions extending back thousands of years. This unusual concentration of Jemez-focused ecological history and research provides potent opportunities to consider the effects of the Las Conchas Fire within a long-term perspective.

So what do we know scientifically about how landscape patterns in the Jemez Mountains have changed through time? How does this long-term perspective frame this book's arresting visual record of the first years following the fire? How does regeneration here resemble other regions of the American West?

Some of our deep-time knowledge about past fire effects exists in paleo-environmental records of pollen and charcoal in sediment cores extracted from the Alamo and Chihuahueños bog sites in the Jemez. These records allow reconstruction of climate, vegetation, and fire histories extending back 9,000 and 15,000 years, respectively.

These and other paleo-records of elsewhere in the Southwest show that the cooler, wetter climate at the very end of the last Ice Age was characterized by infrequent fire; this glacial period ended around 11,000 years ago with a rapid transition to the warmer and drier conditions of the modern climate era (the Holocene). Thus emerged our modern Southwest climate of winters with variable amounts of snow, followed by dry spring and early summer conditions, and then lots of lightning with the onset of monsoonal summer rains. This early Holocene climate transition brought more fire activity, at first likely including some large, high-severity fires in the Jemez that contributed to rapid transformations of late ice-age spruce forests into open, drier forests dominated by ponderosa pine, aspen, oaks, and other tree species better adapted to frequent fires. The sediment cores in both Jemez bogs reveal high levels of charcoal deposits ever since, reflecting the persistent fire-prone nature of these Holocene climate, vegetation, and lightning ignition patterns for approximately the last 9,000 years, with the exception of one recent unique period between about 1880 and 1996, when no charcoal deposition occurred.

CORROBORATING TREE-RING RESEARCH

Another way to reconstruct the history of past fires is by tree-ring dating the burn scars on old wood from live and dead trees. These fire scars can be dated precisely to the years when the trees were injured by fire and even to an approximate season within a year. Tree-ring dating of fire scars in the Jemez is primarily a record of low-severity fires that once burned across its grassy terrain, thinning out young, small trees and thereby limiting the density of forests and

fuel buildup. These fires were generally not hot enough to kill mature trees. Indeed, these pre-1900 fires typically did not even burn out the long-exposed wounds on repeatedly fire-scarred recorder trees. We have dated up to thirty-two (!) different fire years from scars on a single pondersosa pine tree in the Jemez.

Since the 1980s, my colleagues and I, in association with the Laboratory of Tree-Ring Research at the University of Arizona, have incrementally developed the world's most extensive mountain-range-scale, tree-ring fire history for the Jemez Mountains. It provides remarkable detail on the timing and spatial patterns of forest and fire changes. This dendrochronological fire-scar record currently includes more than 10,000 dated fire scars from more than 1,300 sampled trees, with many sampled trees recording fires back to ca. 1600 CE. The earliest dated Jemez fire scar documented thus far is from 1125 CE.

This extensive tree-ring history of fire includes many samples from trees adjoining the two Jemez paleo-sediment bog sites. Overall, it strongly confirms two key features of the bog charcoal records: the high frequency of surface fires between at least 1600 and the late 1800s and the subsequent period until about 1996 with its unique absence of widespread fires. This historically anomalous cessation of frequent spreading surface fires was initially caused by overgrazing of grassy surface fuels by sheep and cattle, later followed by land managers' increasingly intense efforts to suppress all fire activity in the Jemez. Remember Smokey Bear of the U.S. Forest Service saying: "Only YOU can prevent forest fires!" The resulting absence of natural tree-thinning surface fires for at least a century caused major fuel buildups, which increased the risk of widespread, high-severity, canopy fires.

Our network of tree-ring fire-scar samples, distributed across the forested portions of the Jemez Mountains, also allows us to reconstruct the minimum sizes of past fires in this landscape. One striking finding of this research is that pre-1900 surface fires in the Jemez commonly were even larger in area than the Las Conchas Fire, which, at 158,753 acres burned, had been widely proclaimed in 2011 as "the largest fire in New Mexico's history." These tree-ring records, however, also show that pre-1900 fires, while often

quite large, were primarily surface fires burning through open, low-density forests and not spreading through forest canopies as tree-killing fires.

HOTTER AND DRIER

Climate, too, is a key driver of fire activity, and this is where tree-ring research provides additional insights. Using tree-ring growth patterns, it is possible to reconstruct climate fluctuations during the past 2,000 years in central New Mexico and for about 1,000 years in the Jemez region. These high-resolution climate reconstructions clearly show that annual precipitation in this region has been highly variable at all time scales, from seasons to centuries.

Tree-ring records of past precipitation and fires document that year-to-year fluctuations in precipitation largely controlled both the extent and severity of pre-1900 fires. Unsurprisingly, fire activity then was much greater during dry years, just as in modern times. Longer-term regional variability in climate also includes oscillations between relatively wet and dry decades several times per century, linked to similarly oscillating patterns of sea-surface temperature in the Pacific Ocean to the west.

We now see that there was such a wet period in the Southwest that lasted from about 1978 through 1995. This was a period of deep winter snowpacks and strong summer monsoons, when suppression of wildland fires was highly effective and local forests grew thick, healthy, and resistant to natural threats. During the late 1990s, however, the Southwest transitioned back to drought conditions that persist today. In addition, pronounced warming in the past thirty years has greatly amplified both chronic and increasingly extreme forest drought stress across the Southwest, such that the period since 2000 includes the worst window for tree-ring growth in at least the past millennium.

Overall, a broad historical perspective shows that the combination of four factors—human-caused fire exclusion, associated buildup of forest density and fuels, climate variability between wet and dry decades, and strongly warming temperatures—has recently resulted in unusually high vulnerability for the Jemez forests, leading to extreme tree mortality from heat stress and drought, outbreaks of

multiple bark beetle species, and high-severity fires such as Las Conchas. And, indeed, the tree-ring deep-time context shows that the huge patches (as large as 30,000 acres) of old pine and fir trees killed by recent high-severity fires in the Jemez are unprecedented in size for at least the past 400 years and likely much longer. Certainly much obvious landscape change has occurred in the Jemez since the onset of persistent drought and severe fires in the last two decades, especially transitions from dense forests to the expansive open shrublands and grasslands highlighted in this volume.

But are these permanent conversions to non-forest vegetation types or just temporary stages in the natural recovery back to forests? The patterns of post-fire vegetation response to the Las Conchas Fire visible in the images by Patricia Galagan and Philip Metcalf offer some clues. In high-elevation, wetter, mixed-conifer forests, an abundance of resprouting aspen and diverse shrubs quickly regenerated in high-severity burn areas, commonly providing lots of vegetation cover within just a year. Despite heavy browsing by elk in some places, this massive pulse of post-fire aspen sprouting looks to have successfully established a new, young forest across large areas. Historically such aspen stands provided cool, moist, partly shady settings ideal for the establishment of new, high-elevation conifers, seeded from pockets of surviving old white fir, Douglas-fir, and spruce trees. Despite the unusually large sizes of high-severity burn patches in these higher mountain forests, there still appears to be hope for conifers to regenerate and regain dominance in at least some higher and wetter sites in the eastern Jemez.

In contrast, severely burned lower-elevation dry forests of ponderosa pine in the Jemez have seen much slower recovery overall, dominated by grasses, forbs, and extensive patches of resprouted oak and locust shrubs, with few surviving mother pines across thousands of acres and almost no natural pine regeneration. At the lowest and driest elevations, piñon-juniper woodlands that were first hit by drought-induced die-off of most all mature piñon in 2002 and that then were literally consumed by extreme Las Conchas Fire activity have been recovering even more slowly, with bare soil still dominating large areas in Fall 2018. Given the near-elimination of mature conifer seed trees in these

areas along with projected climate trends of further warming and drying, recovery of historical dry forests and woodlands appears unlikely for at least centuries on such sites.

What can we reasonably expect to occur in the future? Drier winters and continued year-round warming are projected for New Mexico, resulting in more arid conditions, in general, and more extreme and hotter droughts, in particular. We have already seen that extreme-drought events trigger tipping-point changes in forest-drought stress, outbreaks of bark beetles, forest die-offs, and severe fires. Given ongoing trends and projections for the climate, ecologists expect fewer and shorter trees, increasing outbreaks of insects, and more fires—further favoring resprouting shrubs, herbs, and grasses. Overall, projected climate trends are increasingly bad news for historical forest vegetation in this region, with forests in the Southwest already being forced into increasingly shrubby and grassy conditions through combinations of drought-and heat-induced forest die-offs and fire.

The photography in this book captures a key pivot point in the aftermath and emerging ecology of this long-forested Jemez landscape, a seven-year window immediately after the powerful reset of an unprecedented fire, when the charred wooden ghosts of the historical former forests persist while new dominant life-forms emerge. This fire-molded landscape evokes both poignant memories of once-glorious ancient forests now forever lost as well as a growing awareness of the increasing inevitability of novel future states—including the prospect of a generally shrubbier future for the Jemez Mountains and for other areas in the Interior West.

Note

Collaboration with the following colleagues was essential to the fire-history research described in this essay: Tom Swetnam, Scott Anderson, Chris Baisan, Ellis Margolis, Kay Beeley, Don Falk, Ramzi Touchan, Kiyomi Morino, Chris Guiterman, Renata Brunner-Jass, James Riser, Tony Caprio, and Josh Farella.

THEGREENFUSE

Patricia Galagan

The force that through the green fuse drives the flower
Drives my green age; that blasts the root of trees
Is my destroyer.
—DYLAN THOMAS

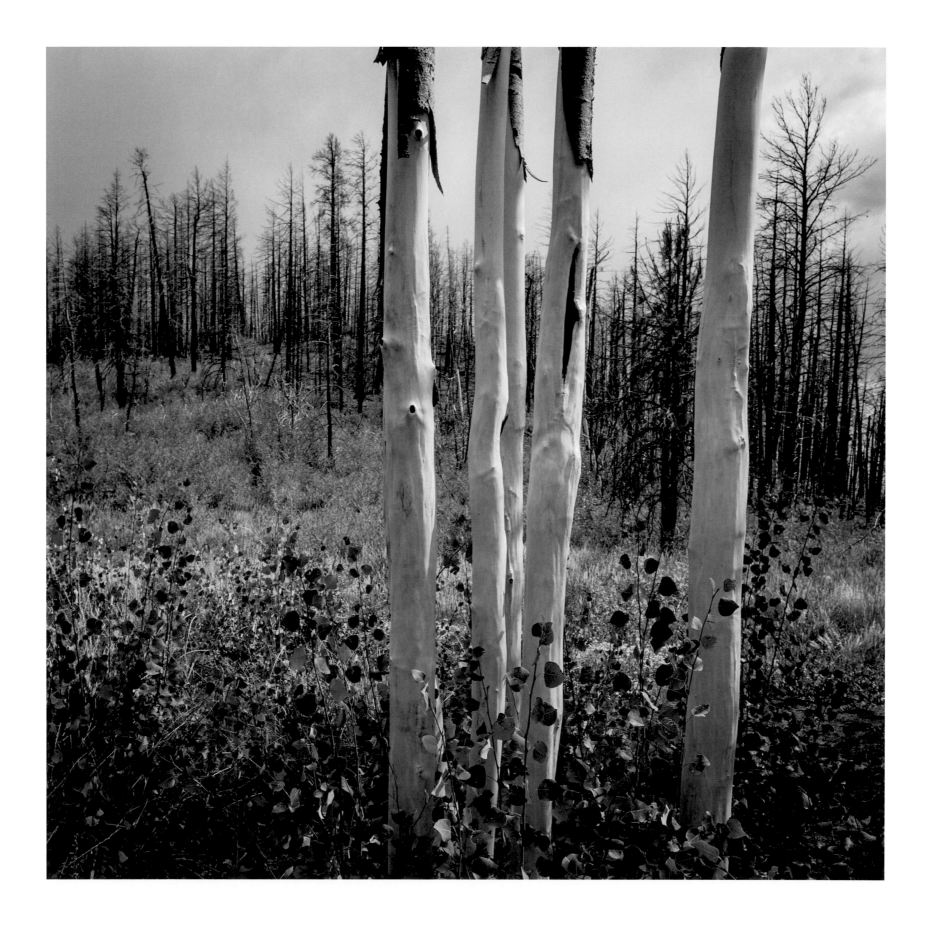

91

RESPROUTING ASPENS ALONG FOREST ROAD 289

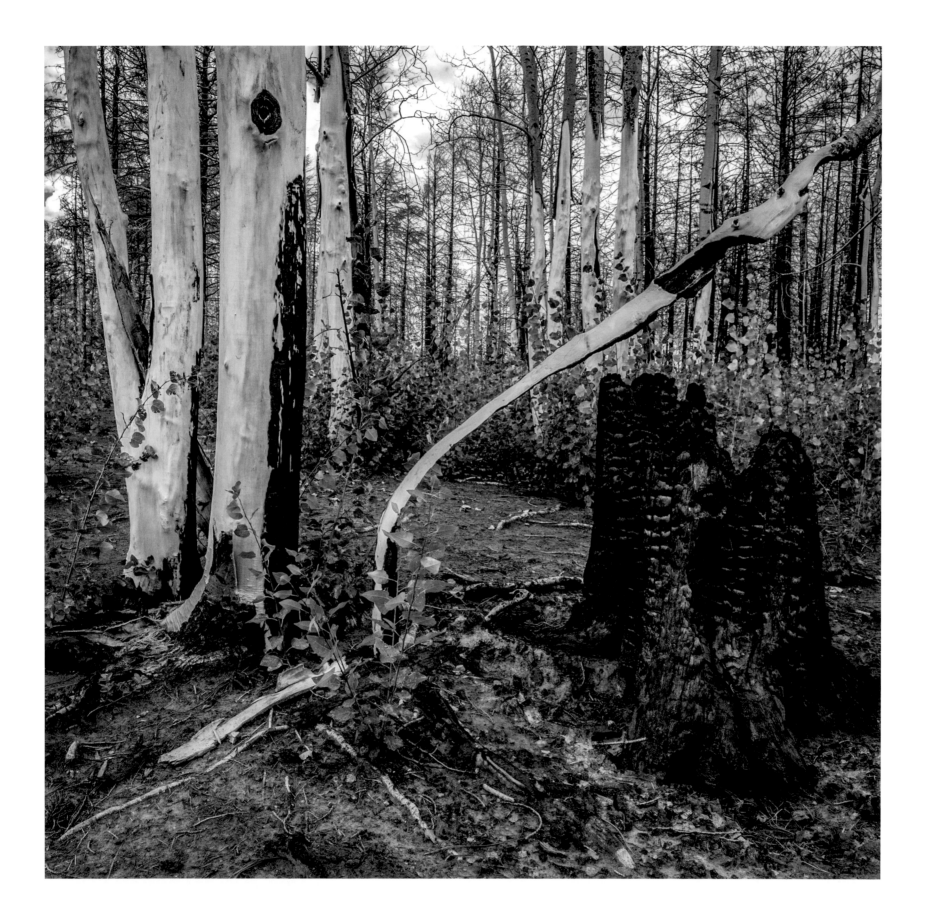

93

BLUE DIAMOND TRAIL, BANDELIER NATIONAL MONUMENT

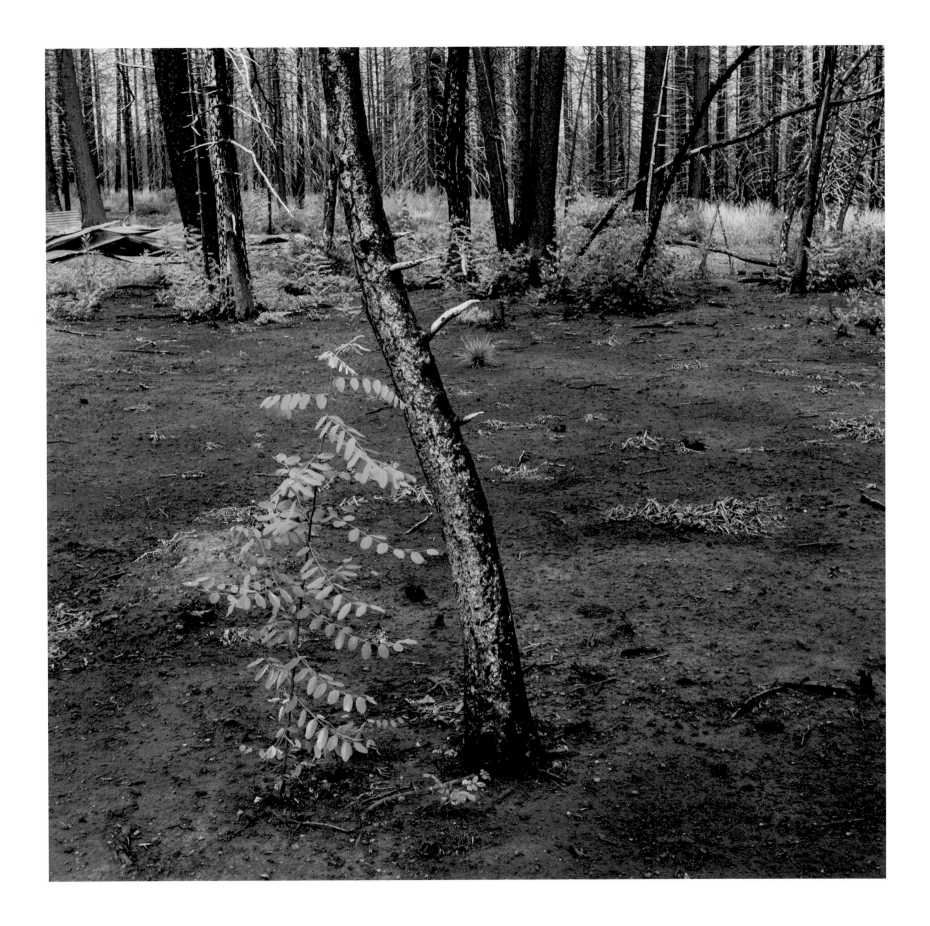

LOCUST SPROUTS, COCHITI MESA

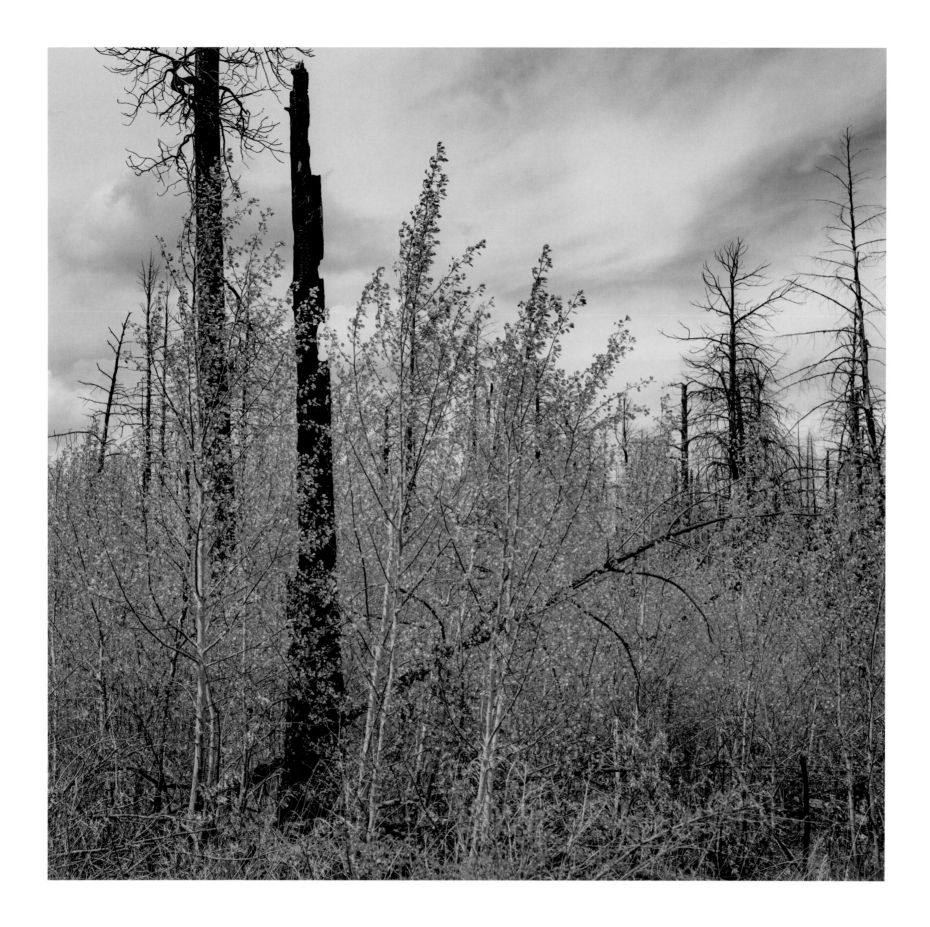

97

ASPENS NEAR SPRUCE CANYON

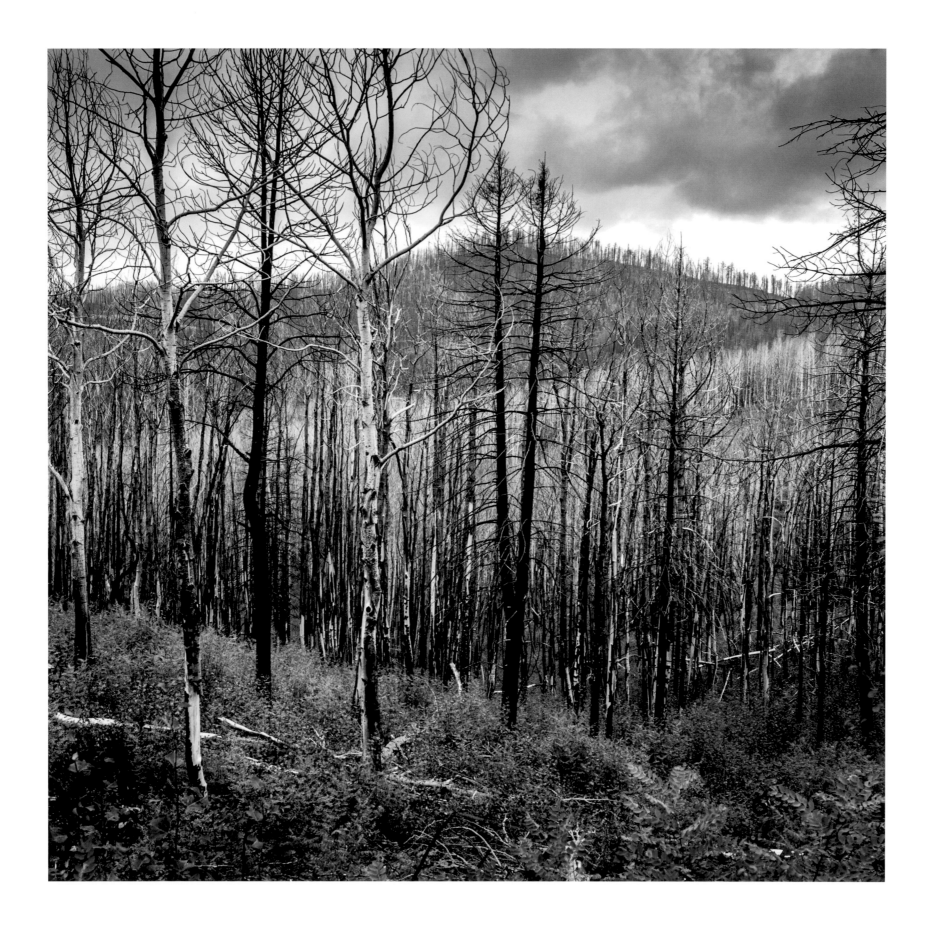

99

ASPENS NEAR LAS CONCHAS MOUNTAIN

Following spread: BANDELIER NATIONAL MONUMENT

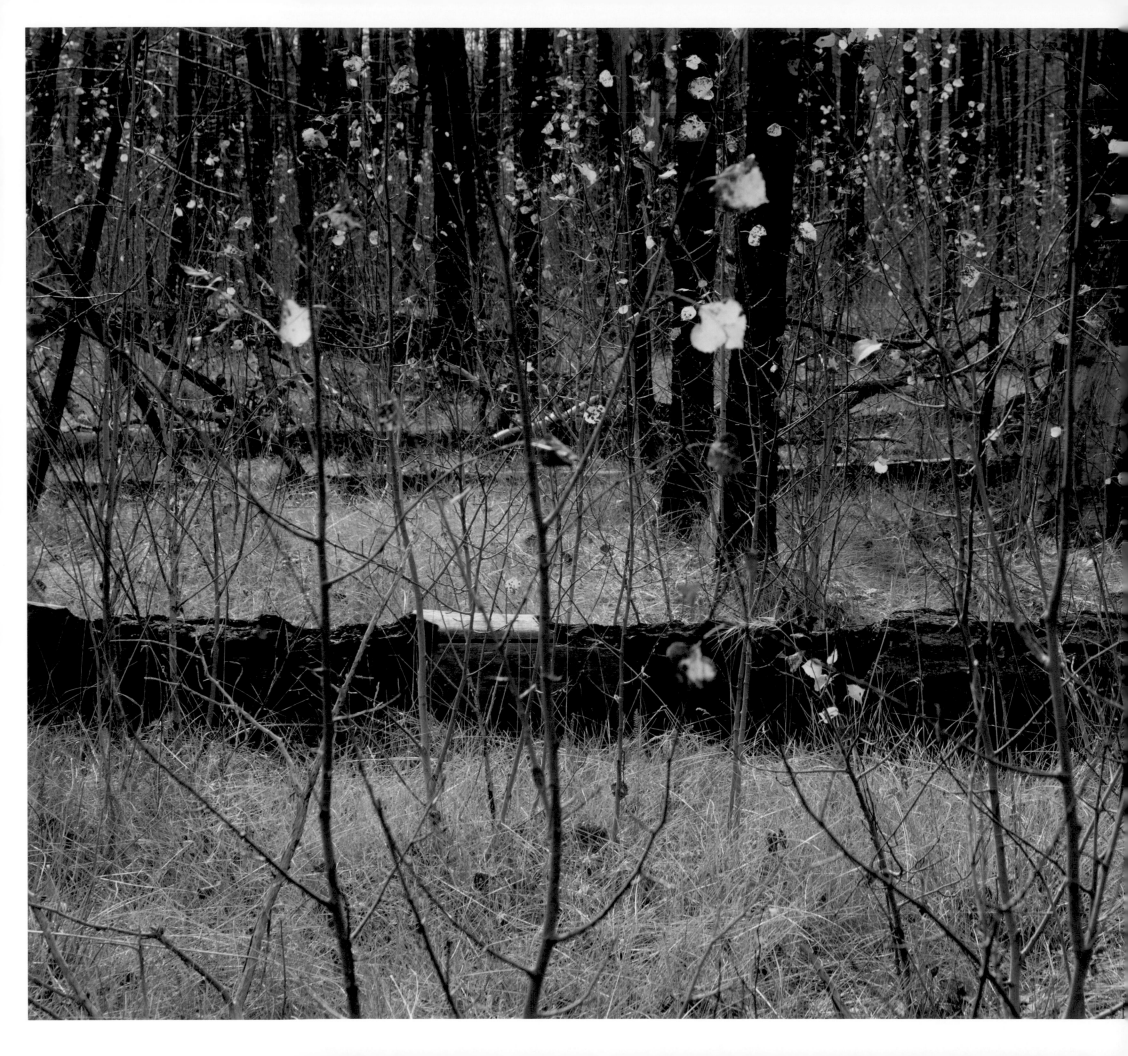

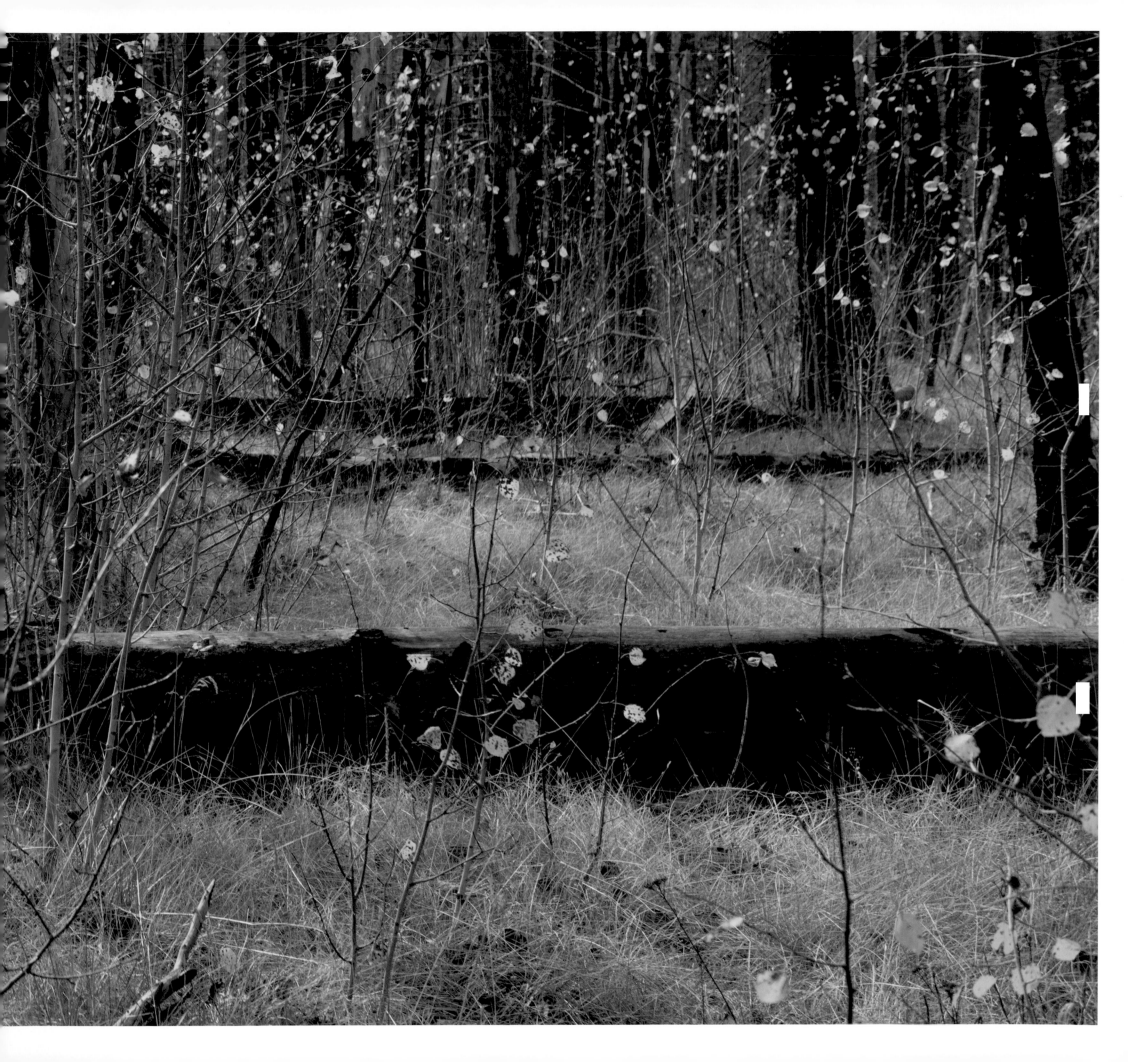

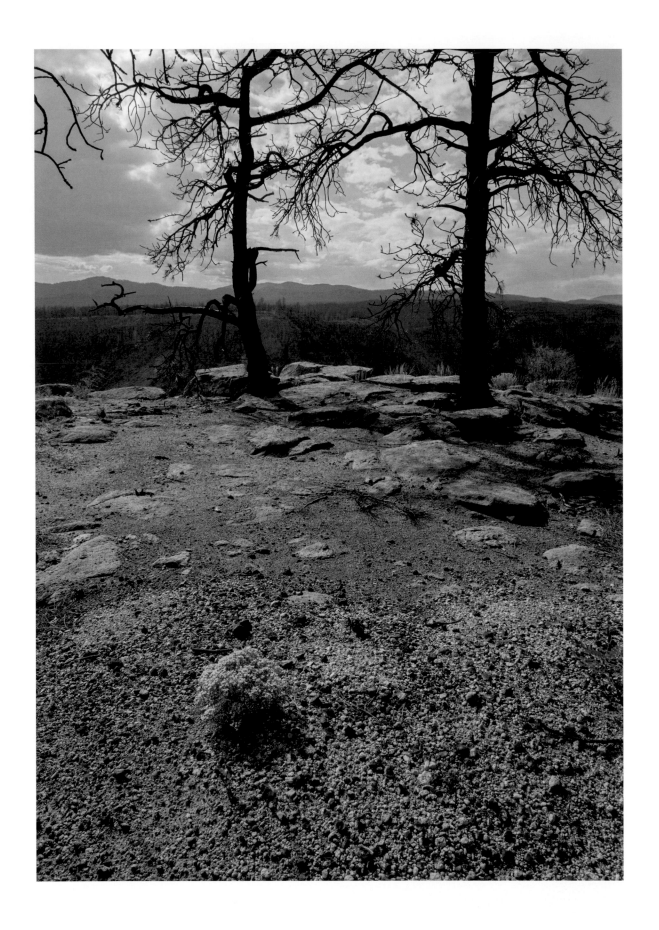

102

COCHITI MESA

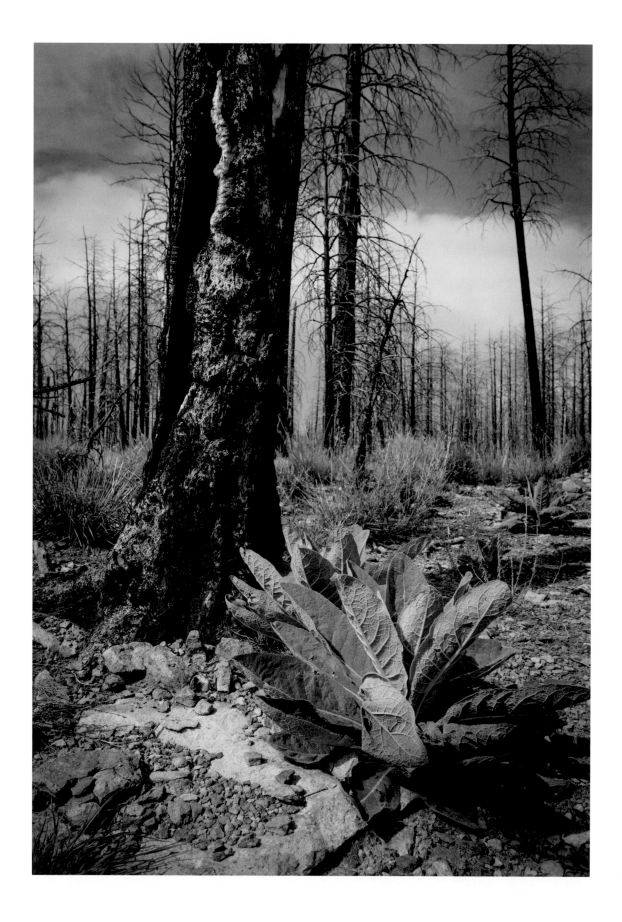

103

NON-NATIVE MULLEINS ON COCHITI MESA

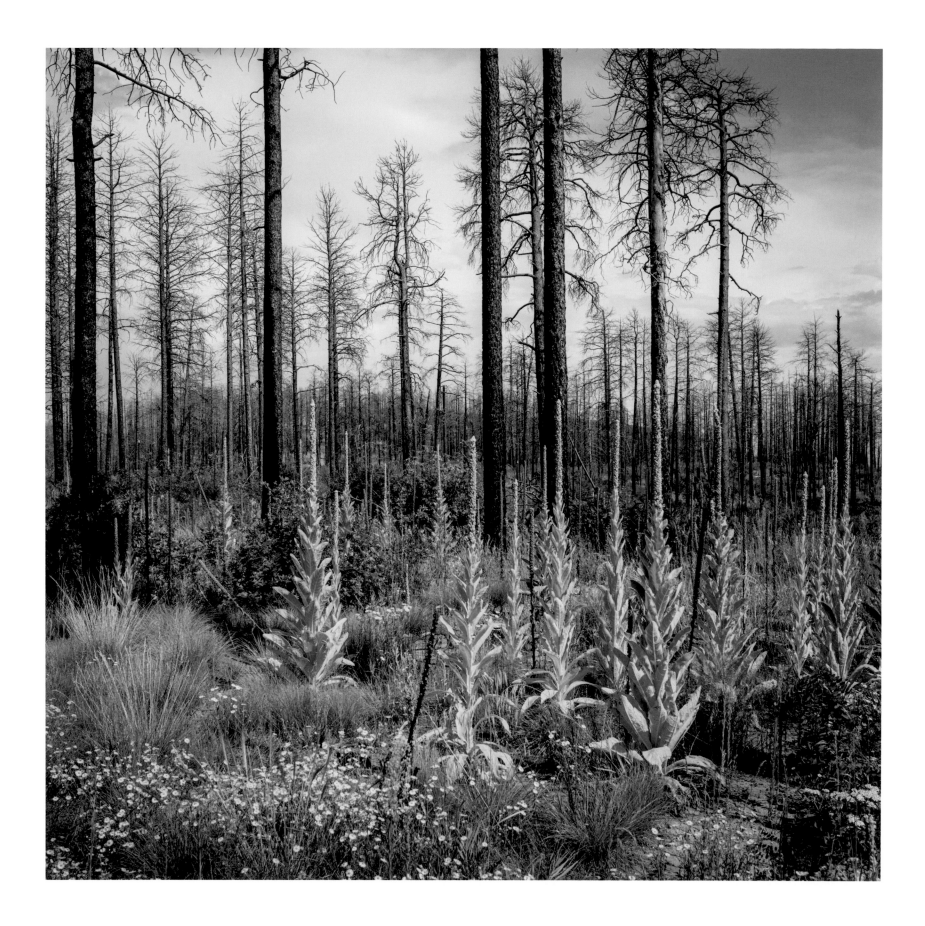

105

NON-NATIVE MULLEINS ON OBSIDIAN RIDGE

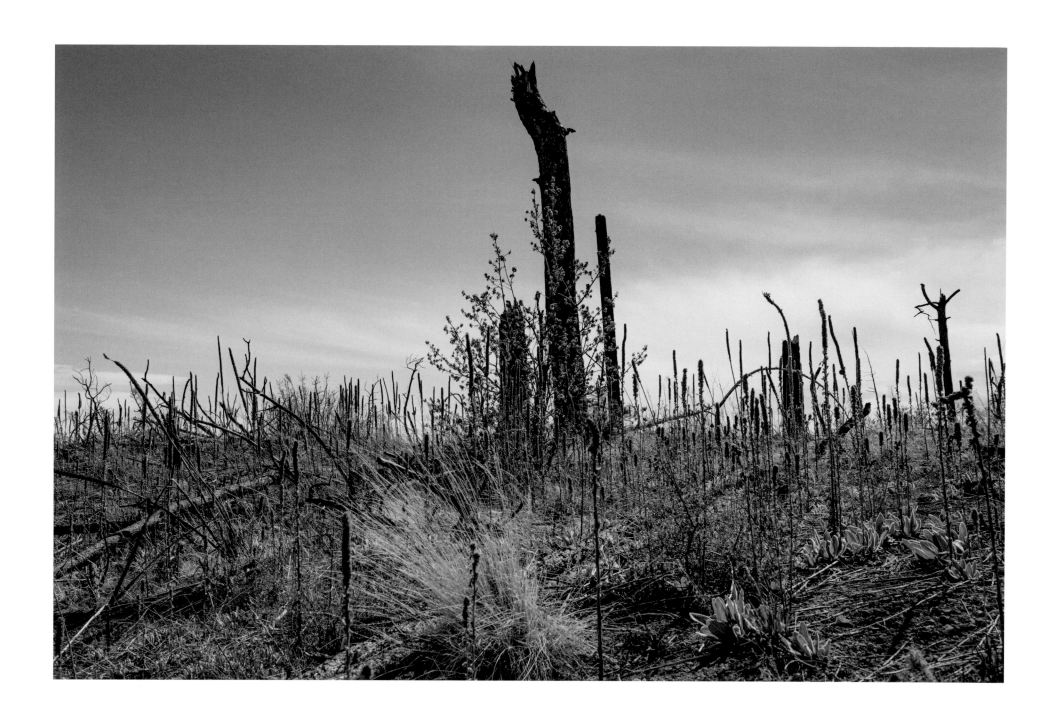

107
NEAR SANCHEZ CANYON

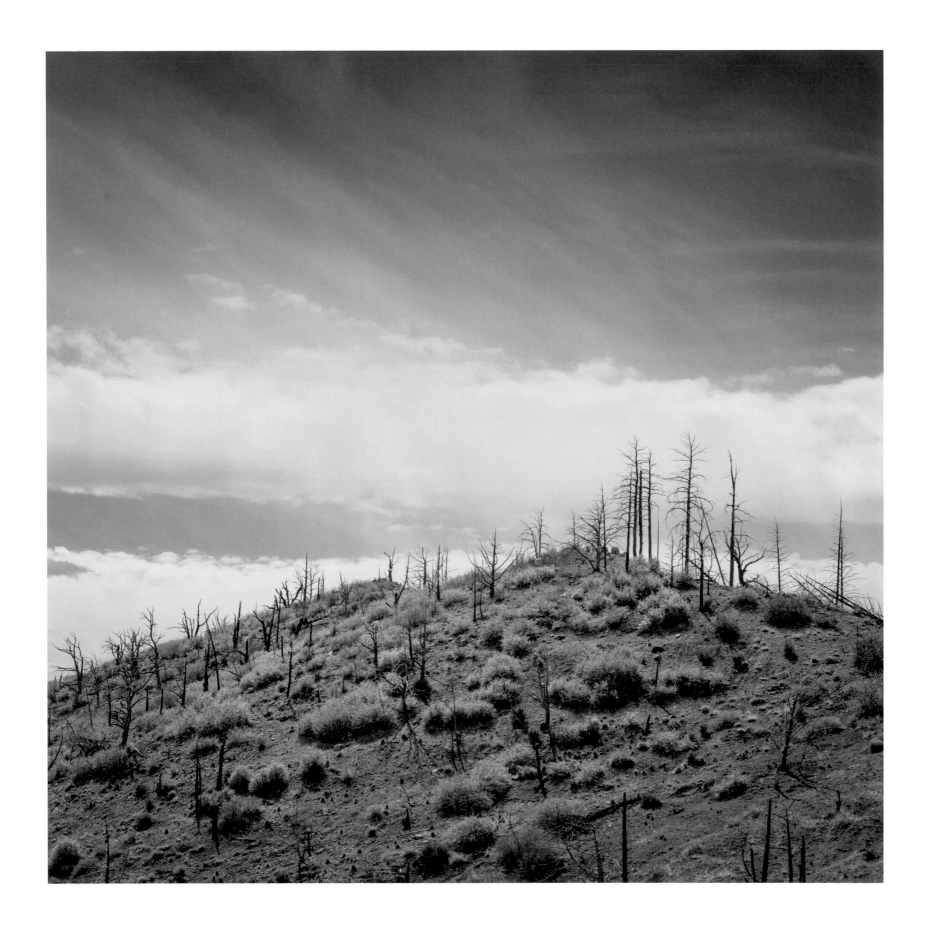

109
NEAR CERRO BALITAS

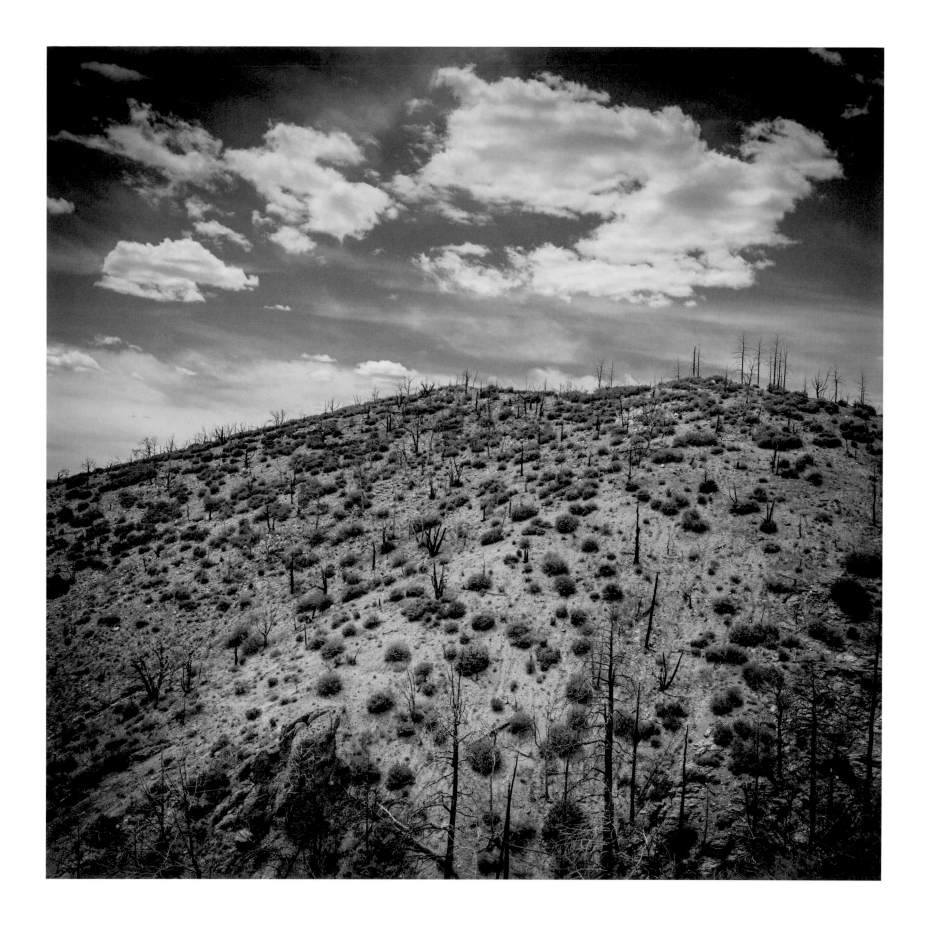

111

SPRING, FIVE YEARS AFTER THE LAS CONCHAS FIRE

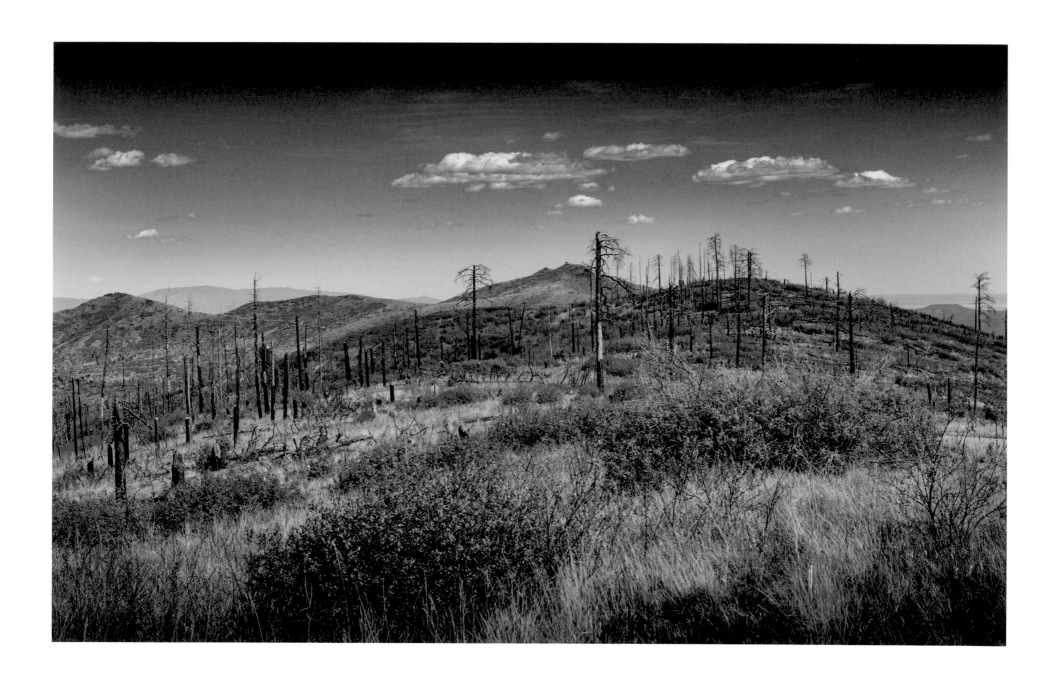

113

GAMBEL OAKS SIX YEARS AFTER THE LAS CONCHAS FIRE

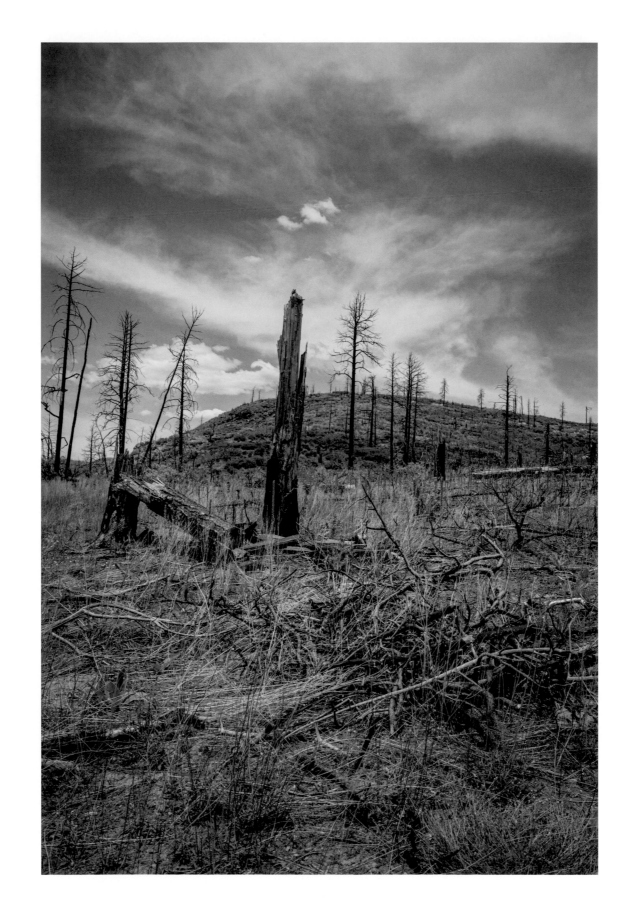

114

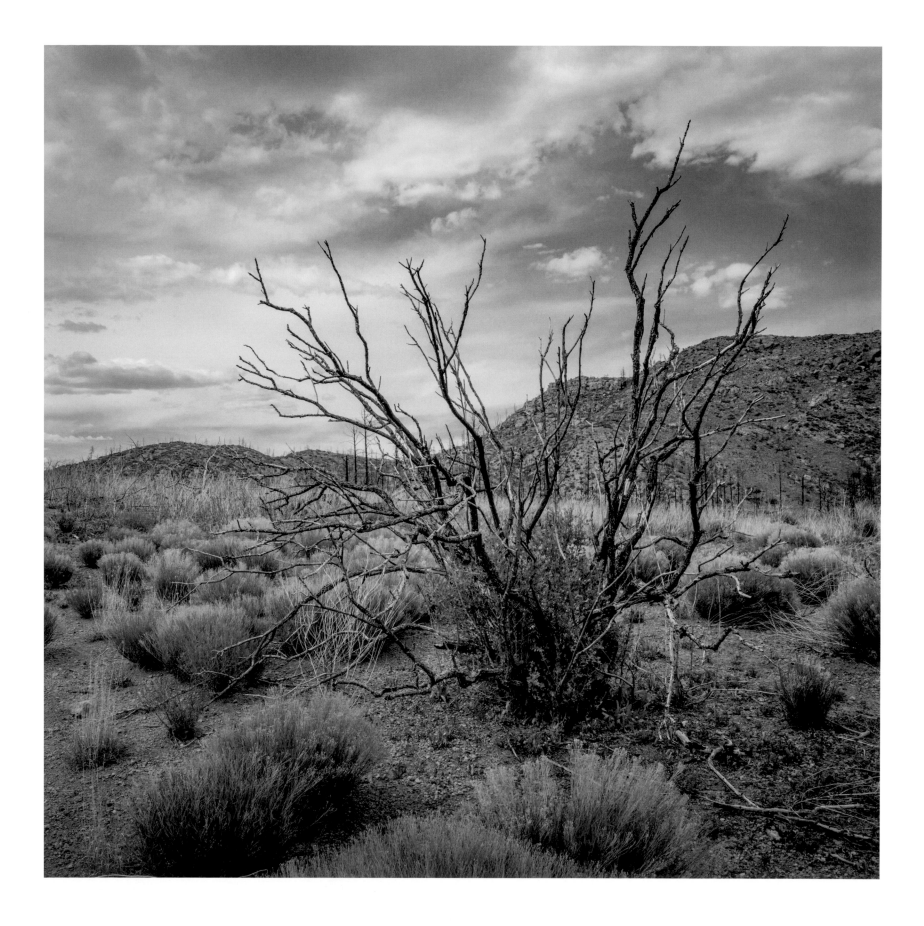

115

MOUNTAIN MAHOGANY AND INVASIVE SNAKEWEED

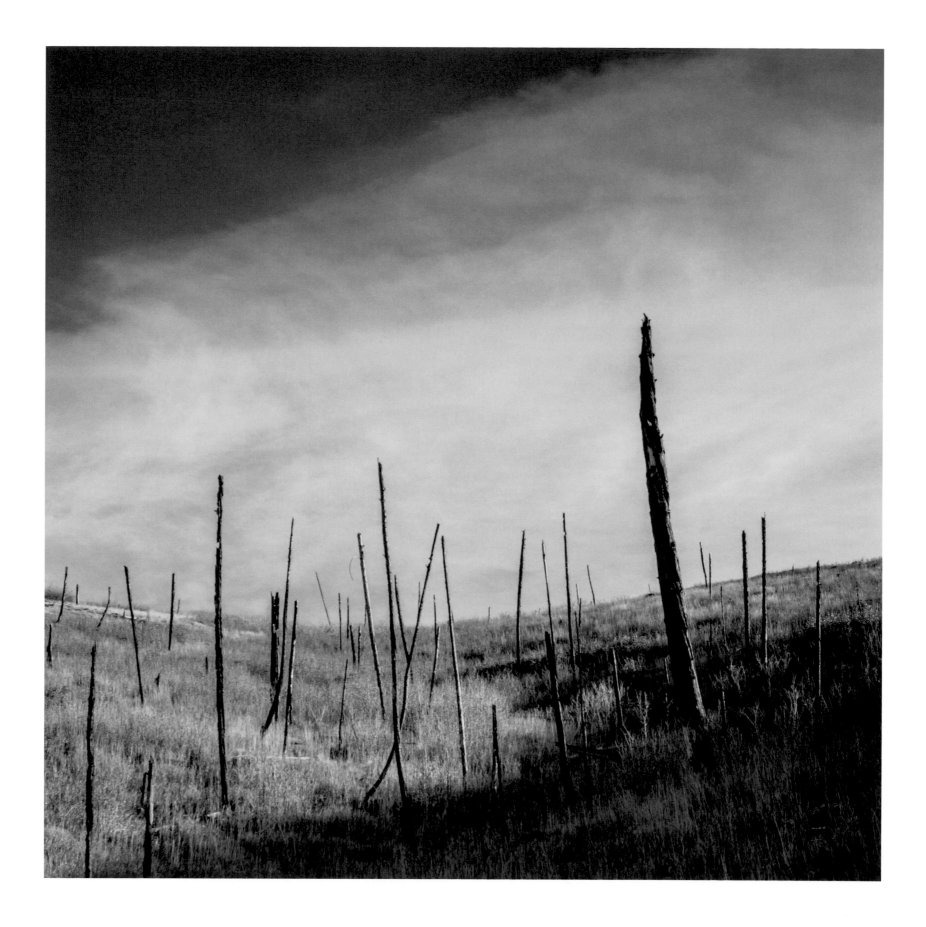

NATIVE GRASSES

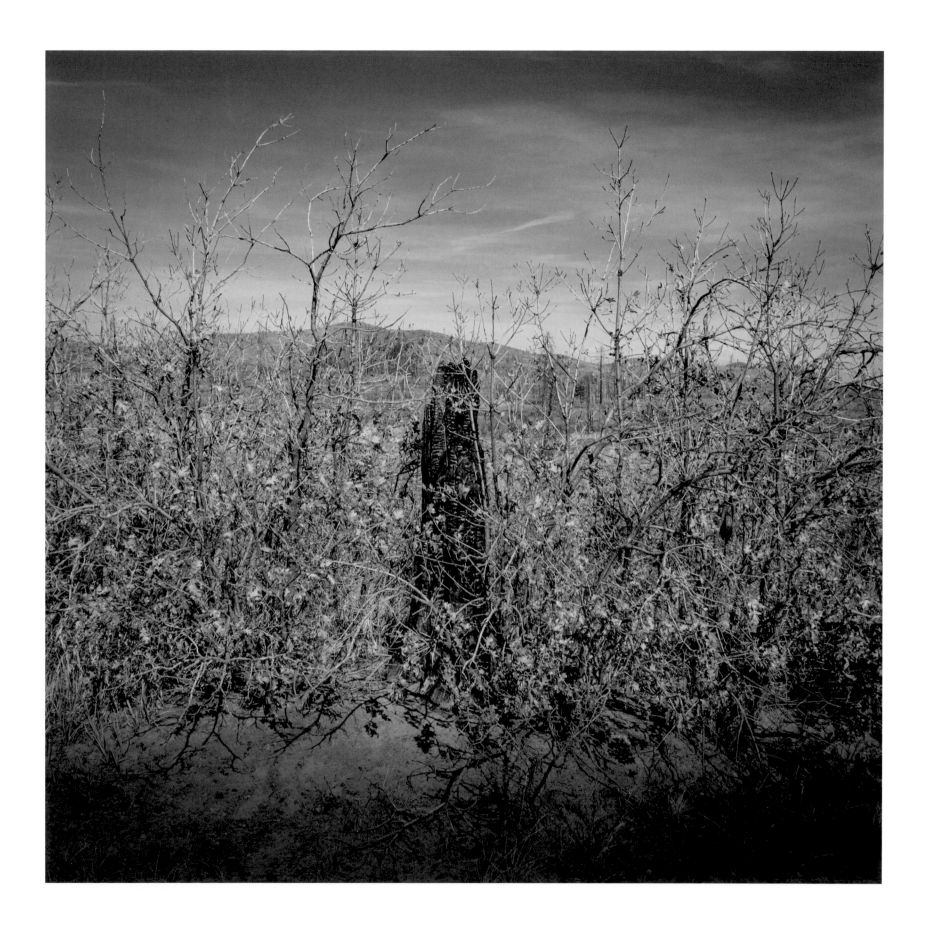

119
GAMBEL OAKS

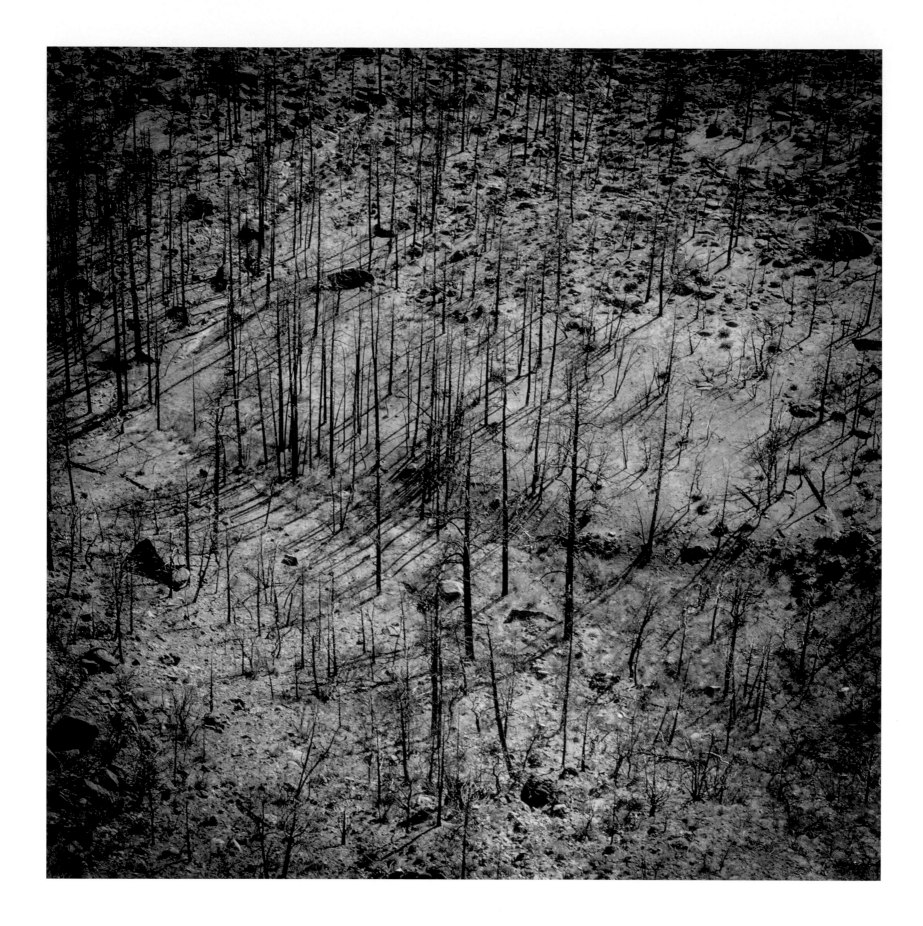

120

FALL, ONE YEAR AFTER THE LAS CONCHAS FIRE

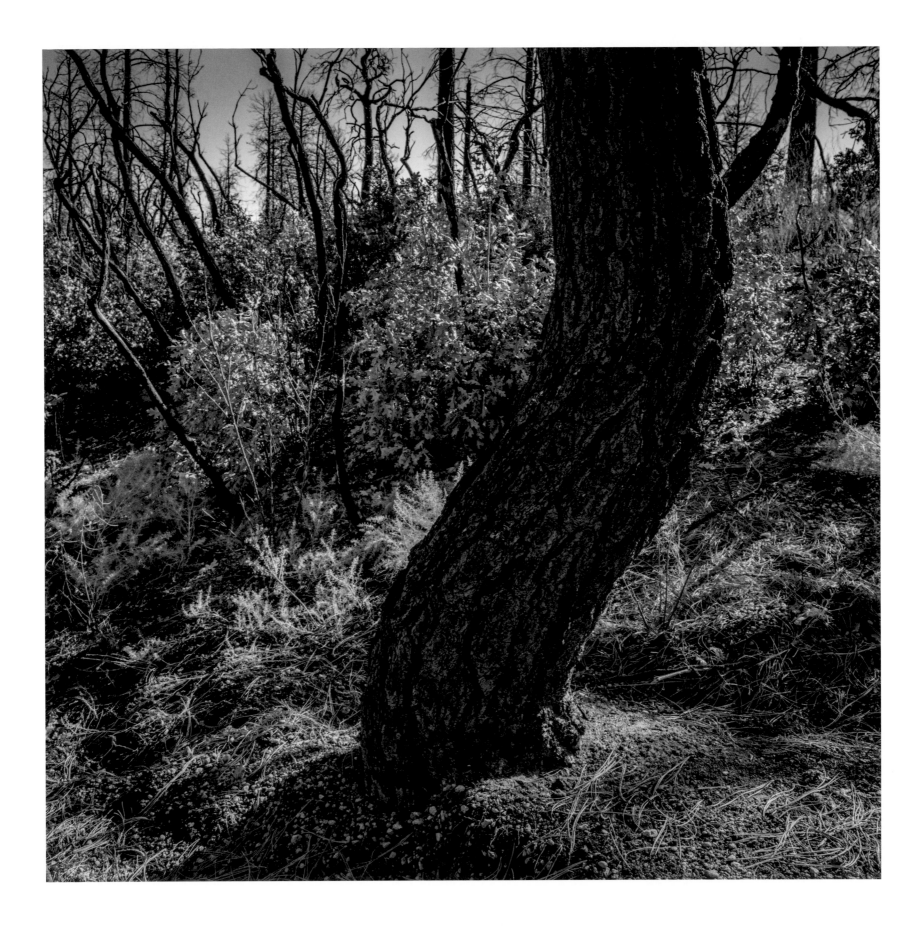

121

PONDEROSA PINE WITH GAMBEL OAKS

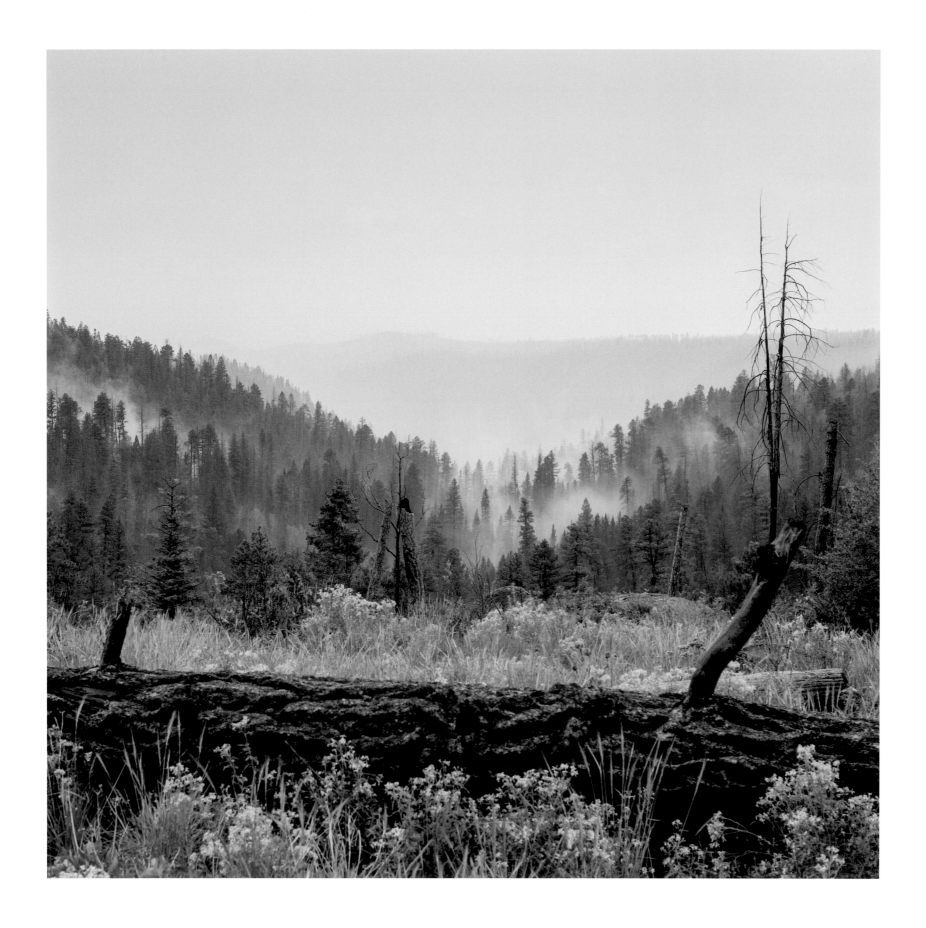

123

FIRST SPRING AFTER THE FIRE

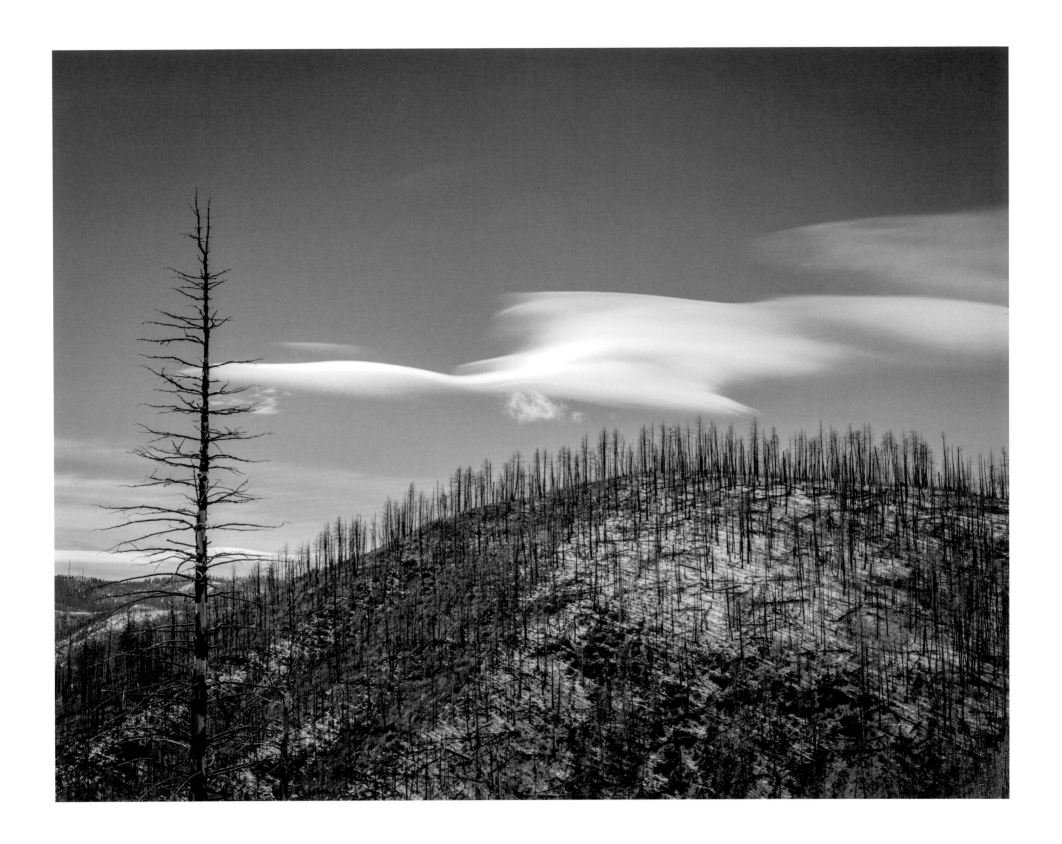

125

NEAR SPRUCE CANYON

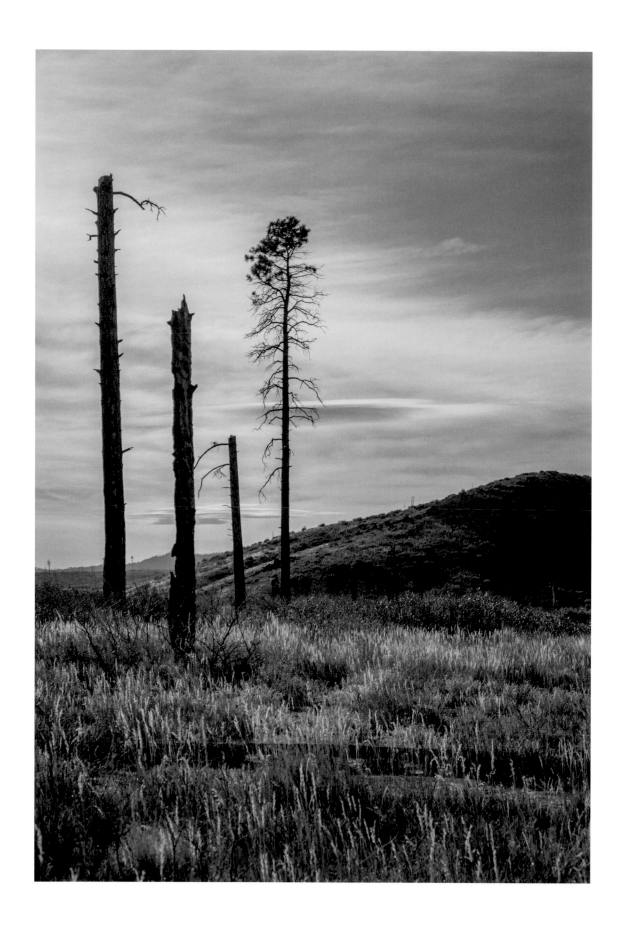

THE DOME WILDERNESS SIX YEARS AFTER THE LAS CONCHAS FIRE

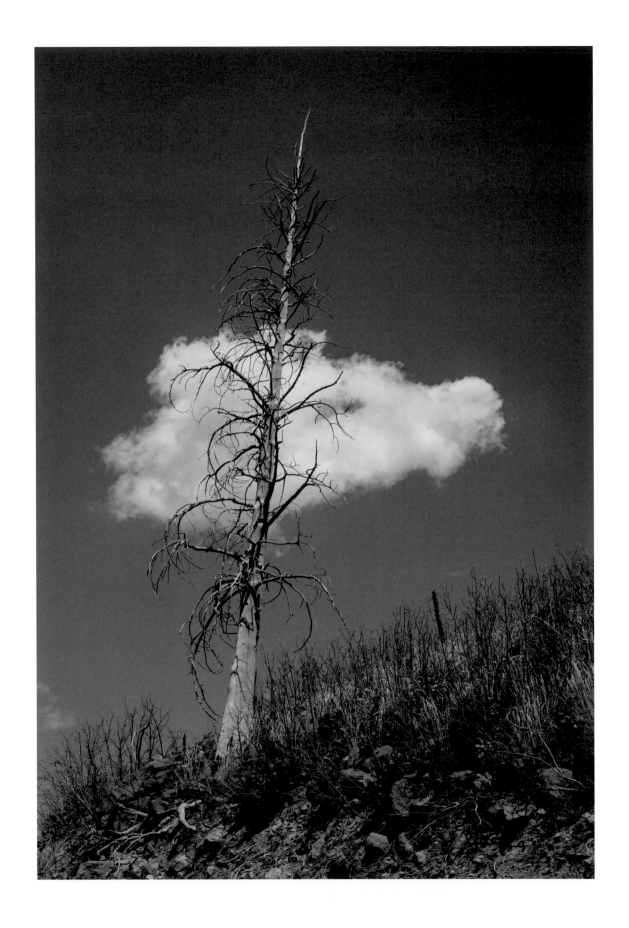

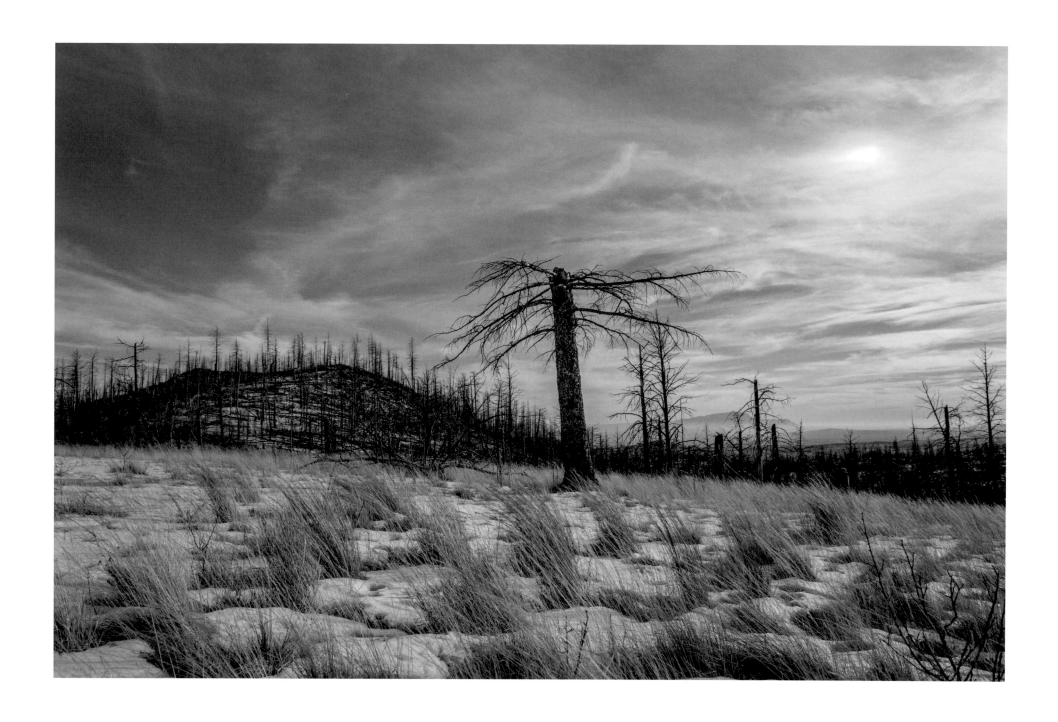

129

WINTER, OBSIDIAN RIDGE

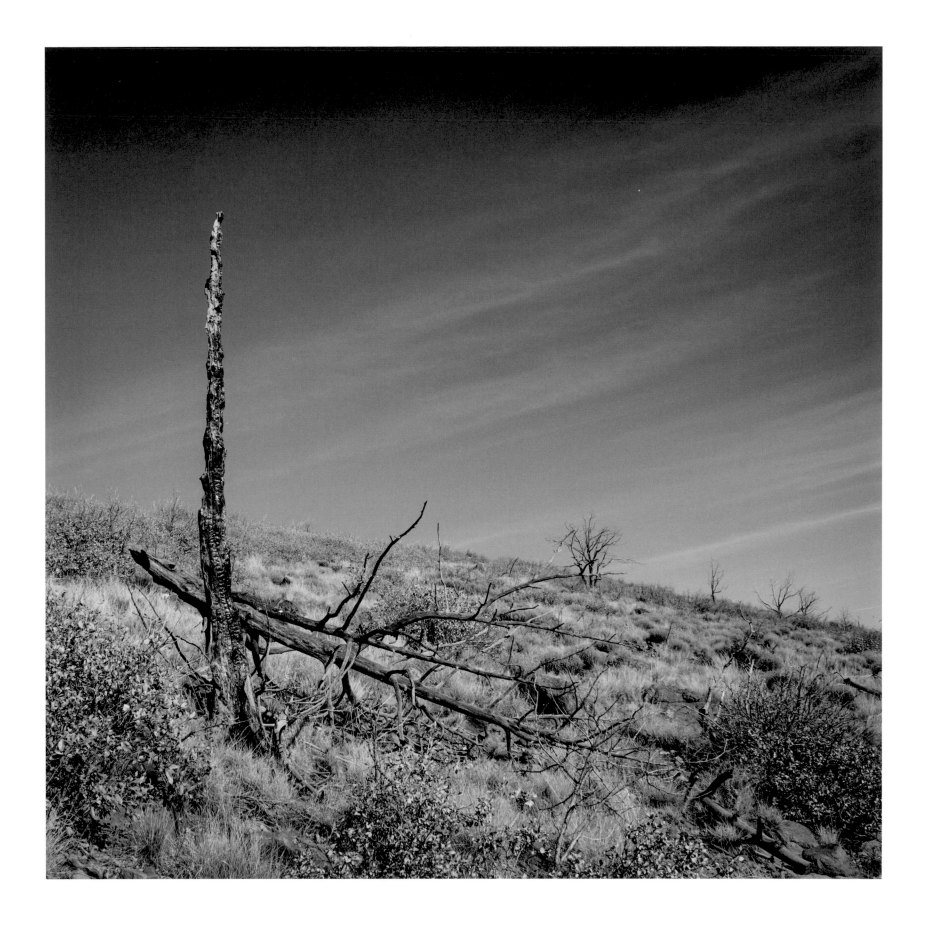

131

GAMBEL OAKS AND BURNED PONDEROSA PINES

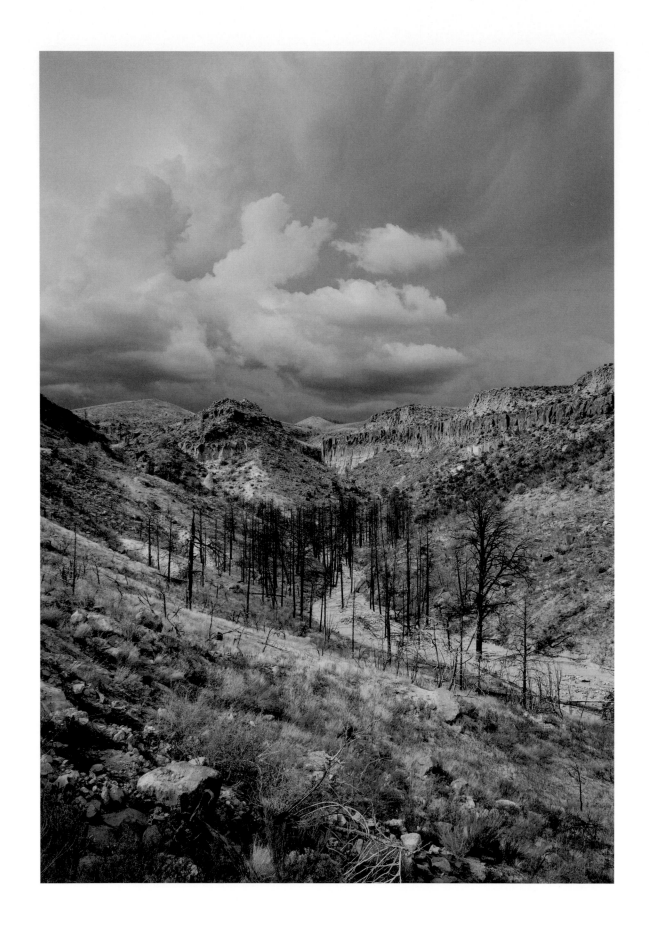

132

EAGLE CANYON

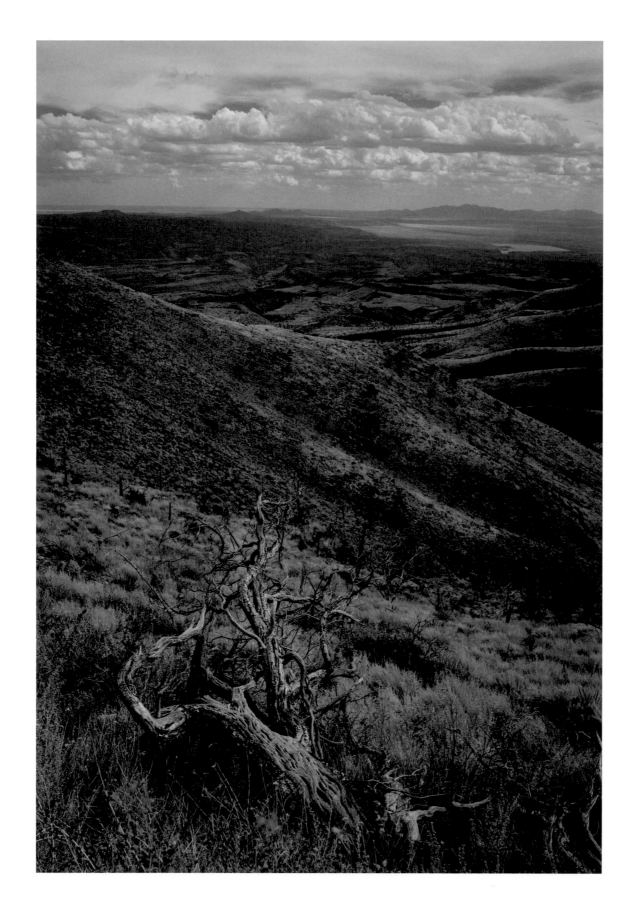

133

NEAR BOUNDARY PEAK, LOOKING SOUTH TO COCHITI LAKE

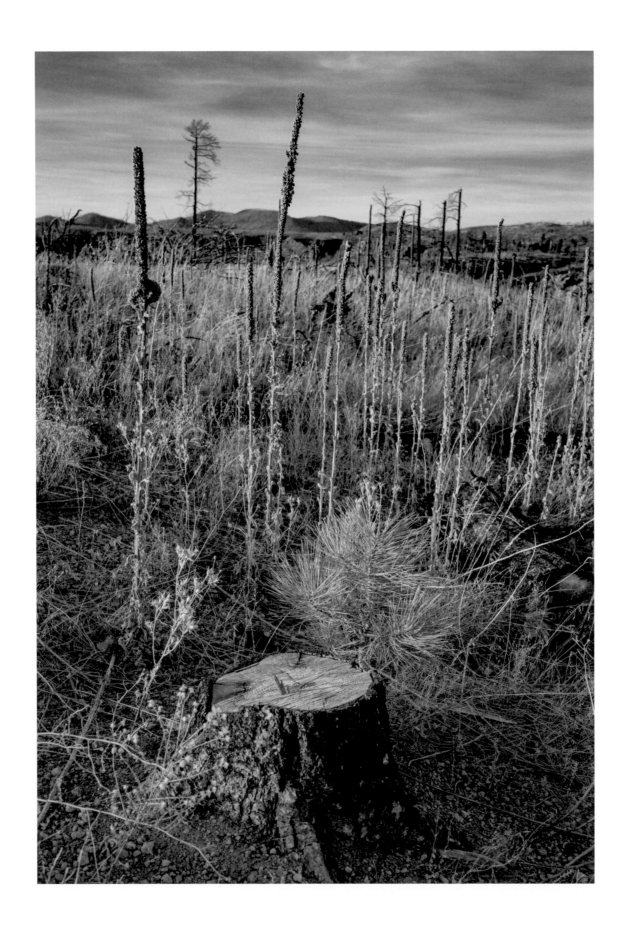

135

RESPROUTING PONDEROSA PINE

Following spread: CAPULIN CANYON

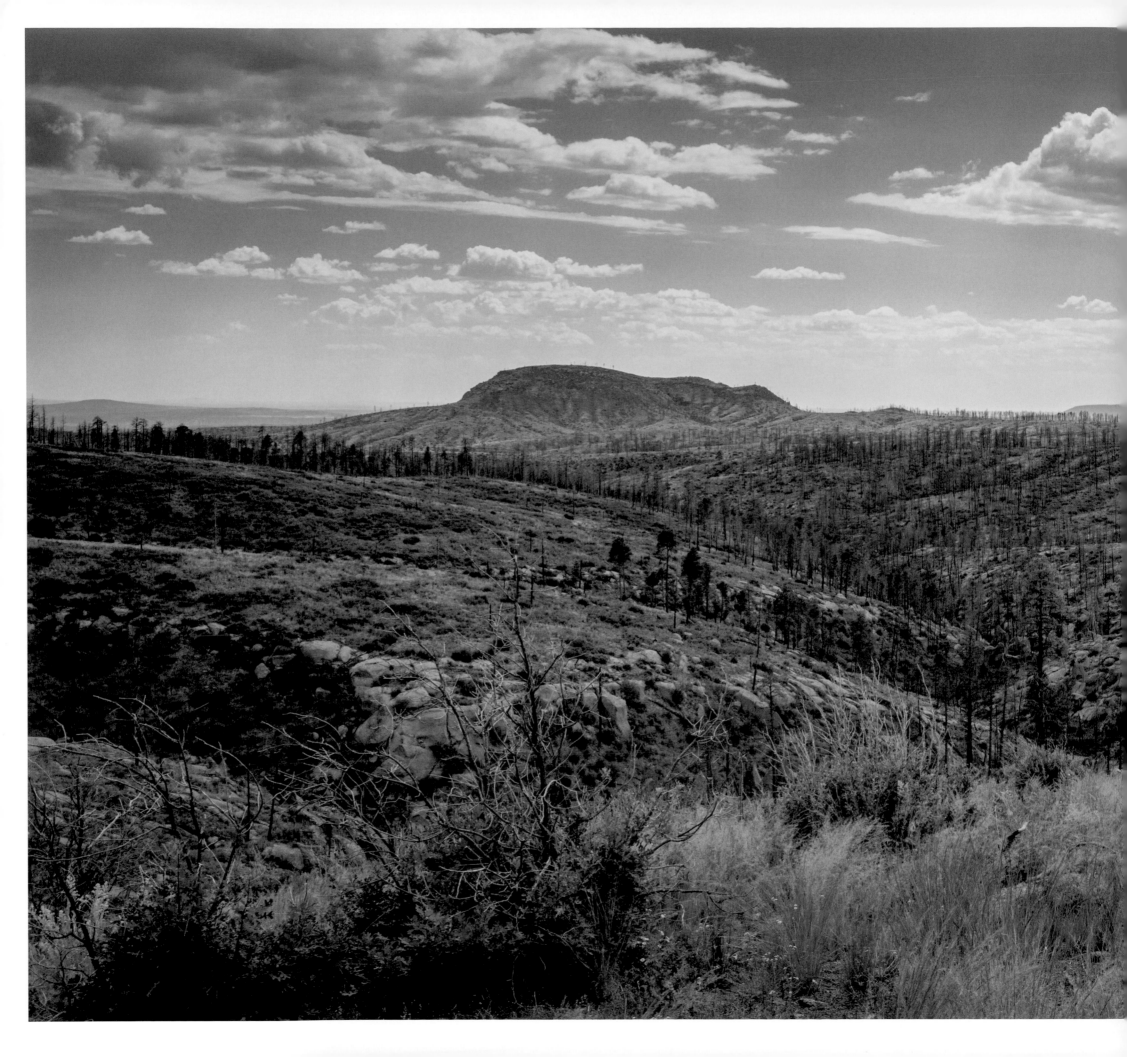

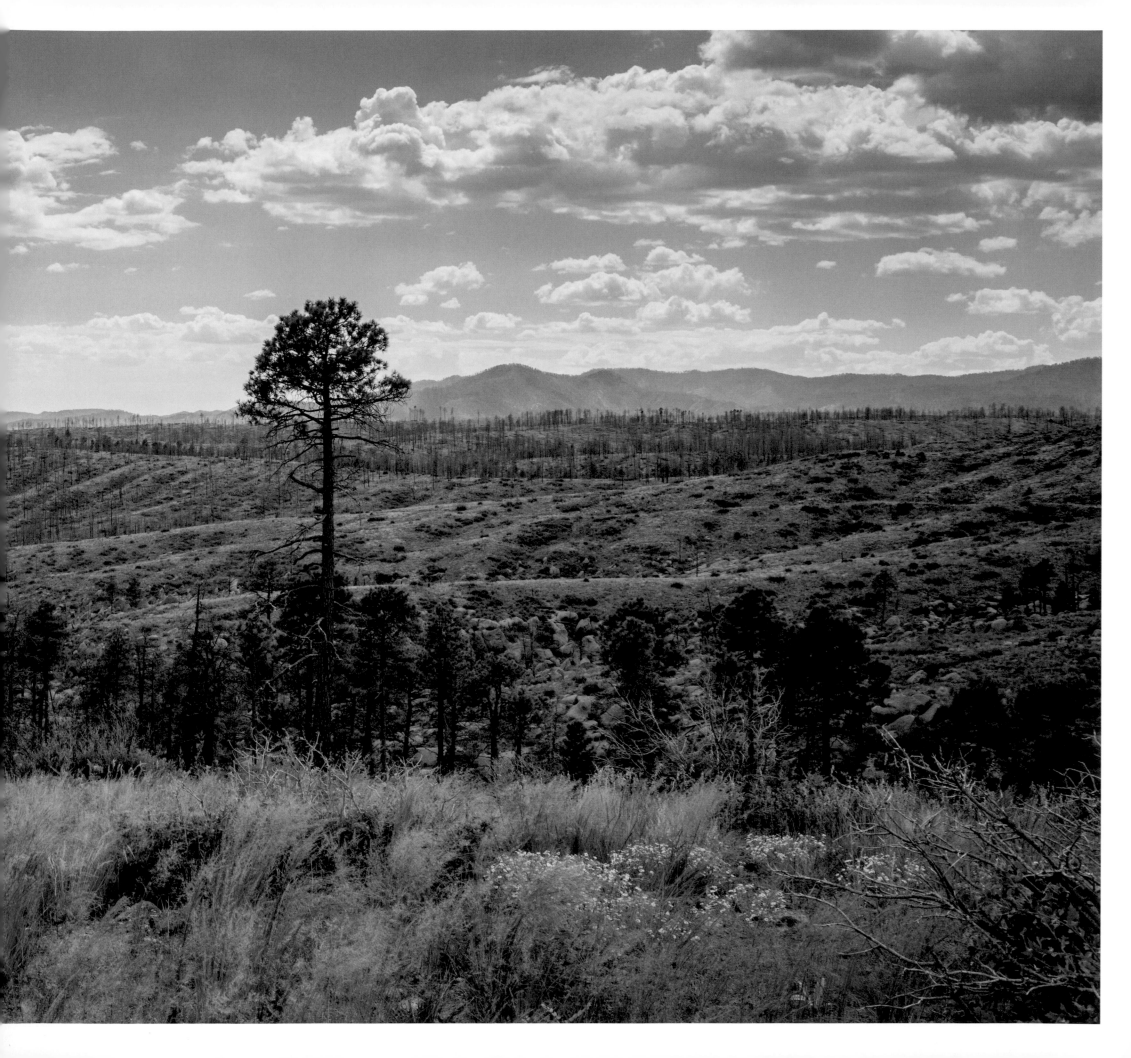

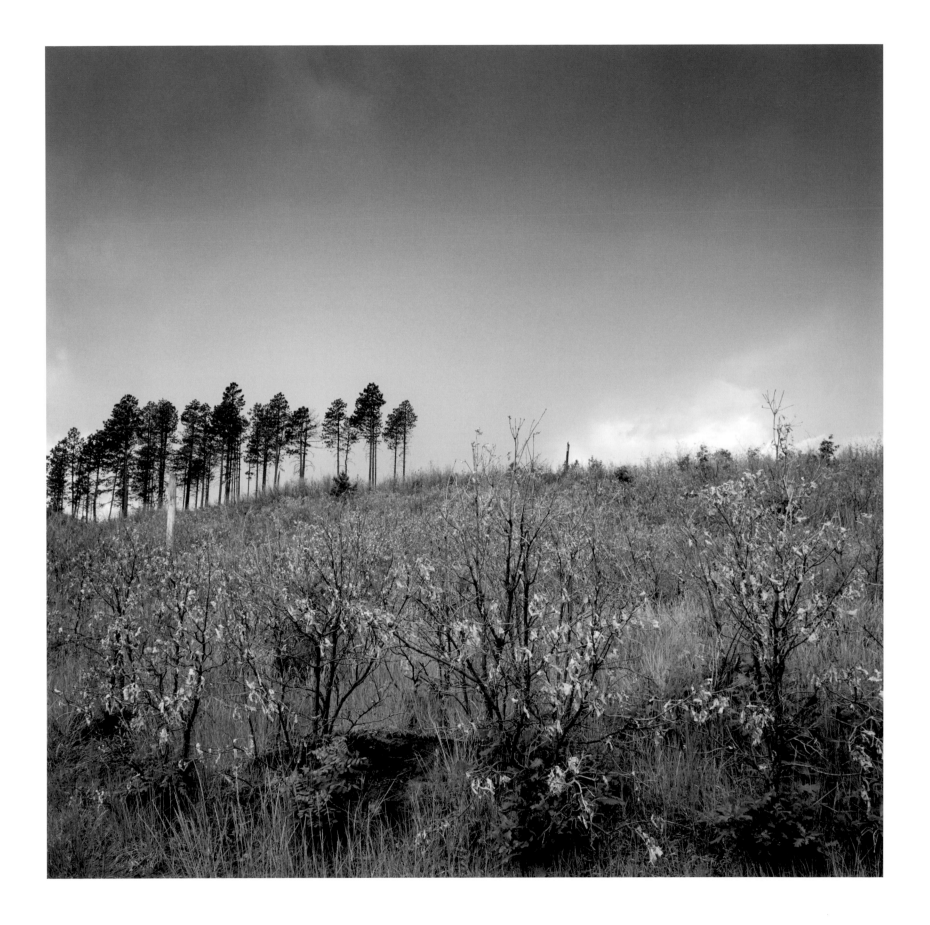

139
GAMBEL OAKS AND PONDEROSA PINES

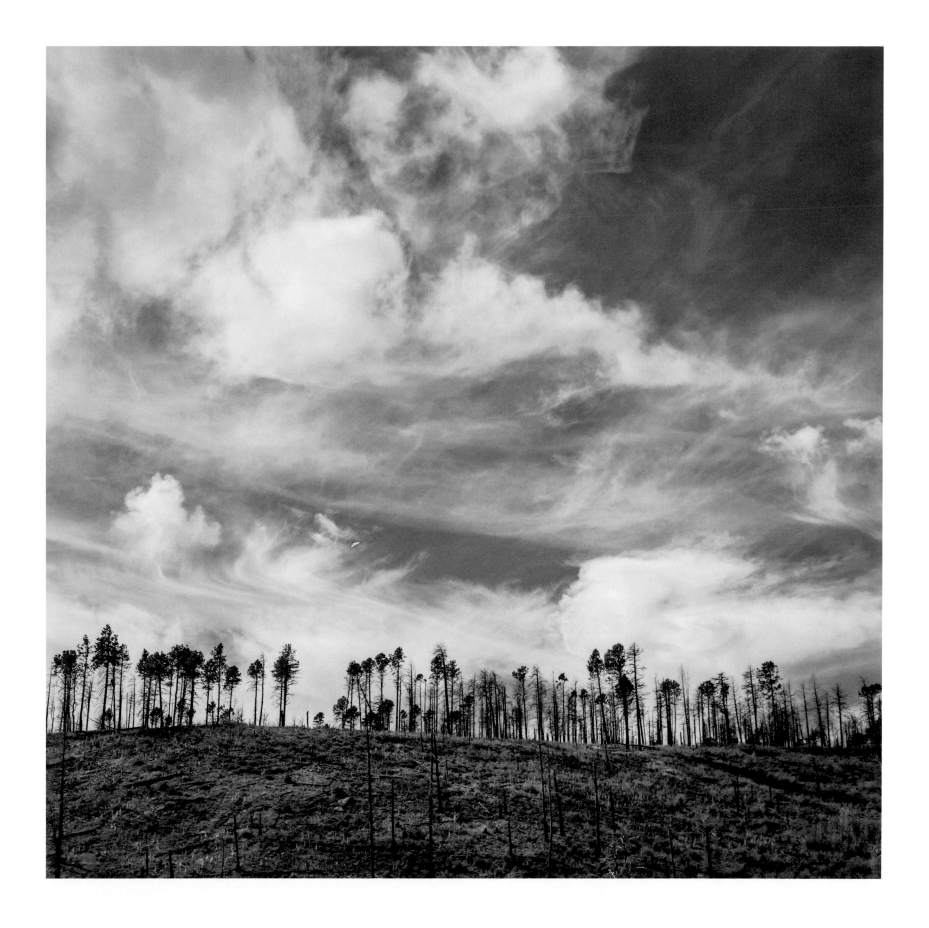

141

APACHE MESA, BANDELIER NATIONAL MONUMENT

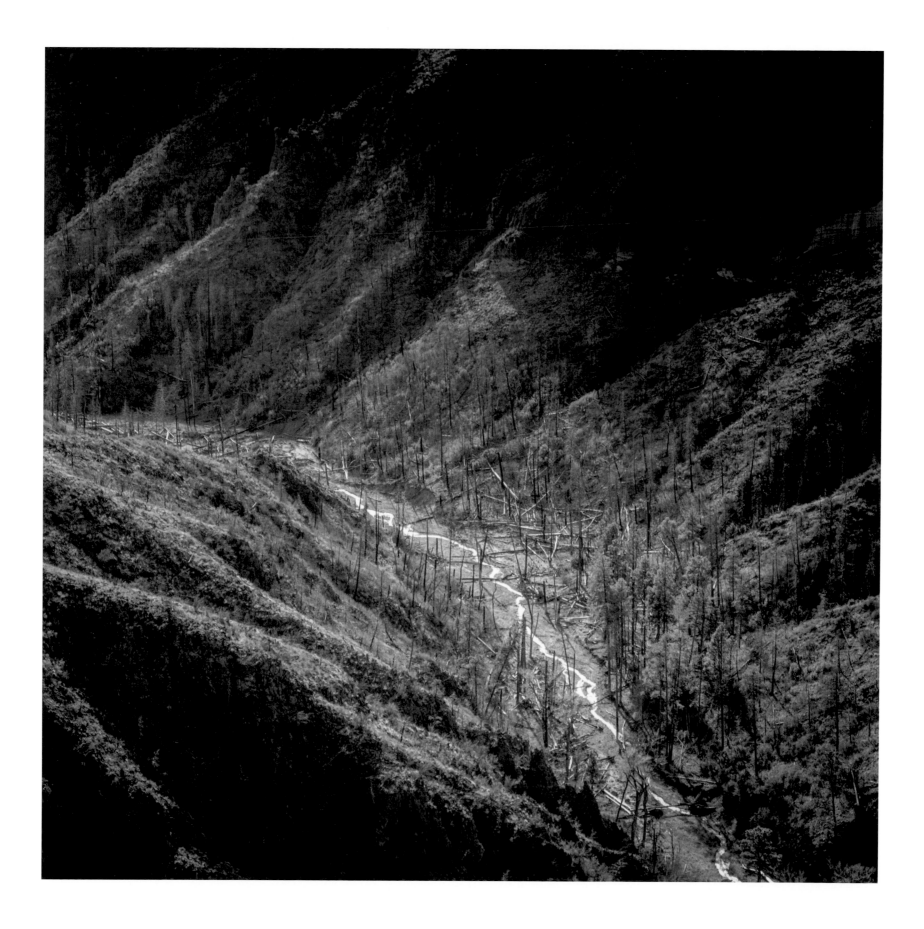

143
COCHITI CANYON

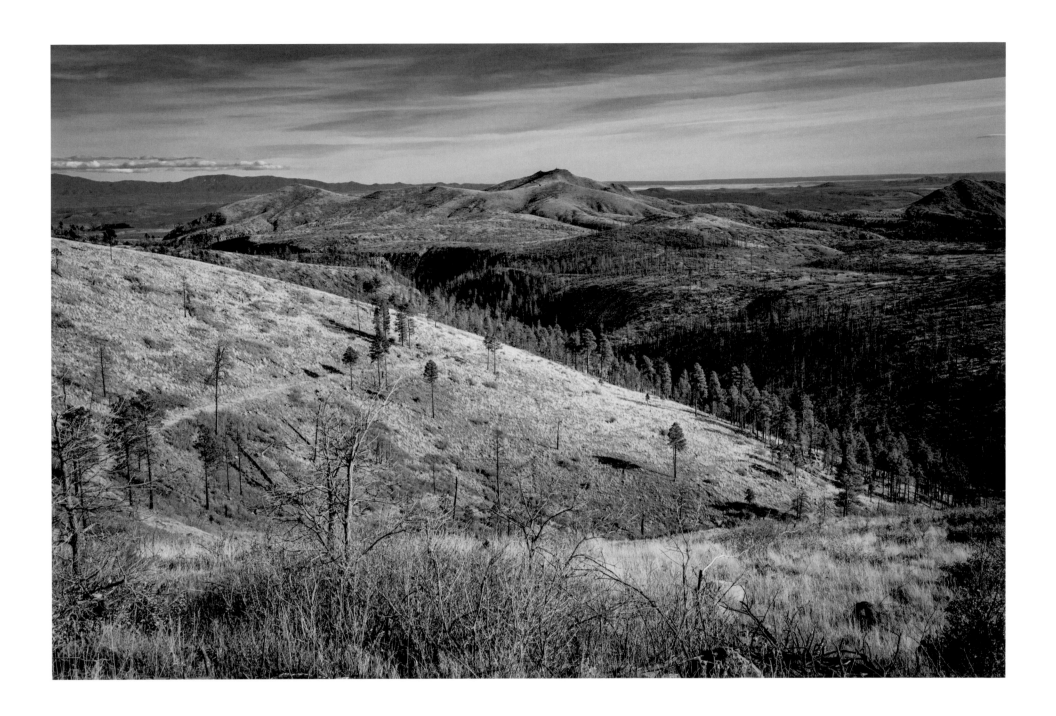

145

CAPULIN CANYON

Following spread: SANTA FE NATIONAL FOREST SIX YEARS AFTER THE LAS CONCHAS FIRE

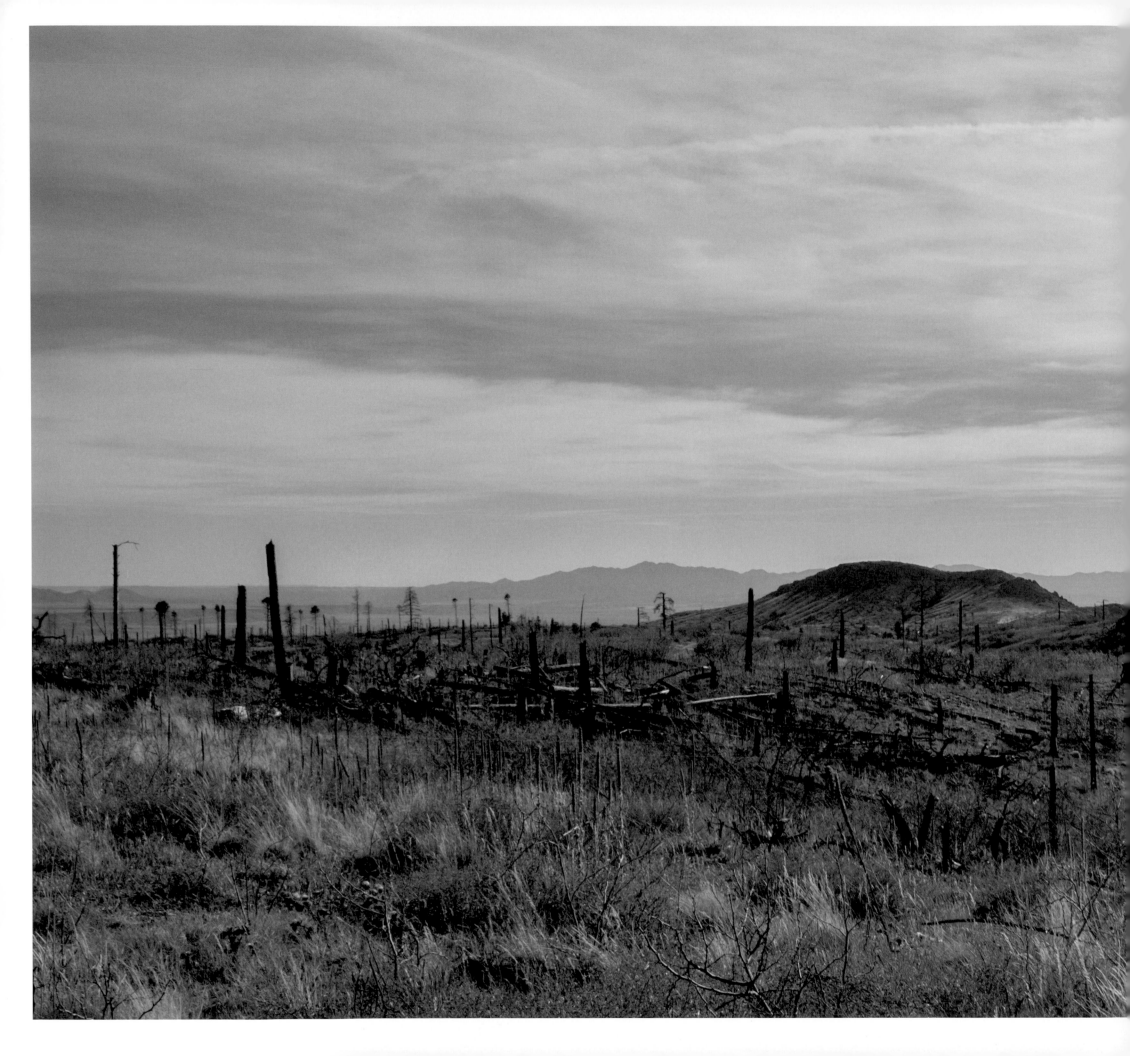

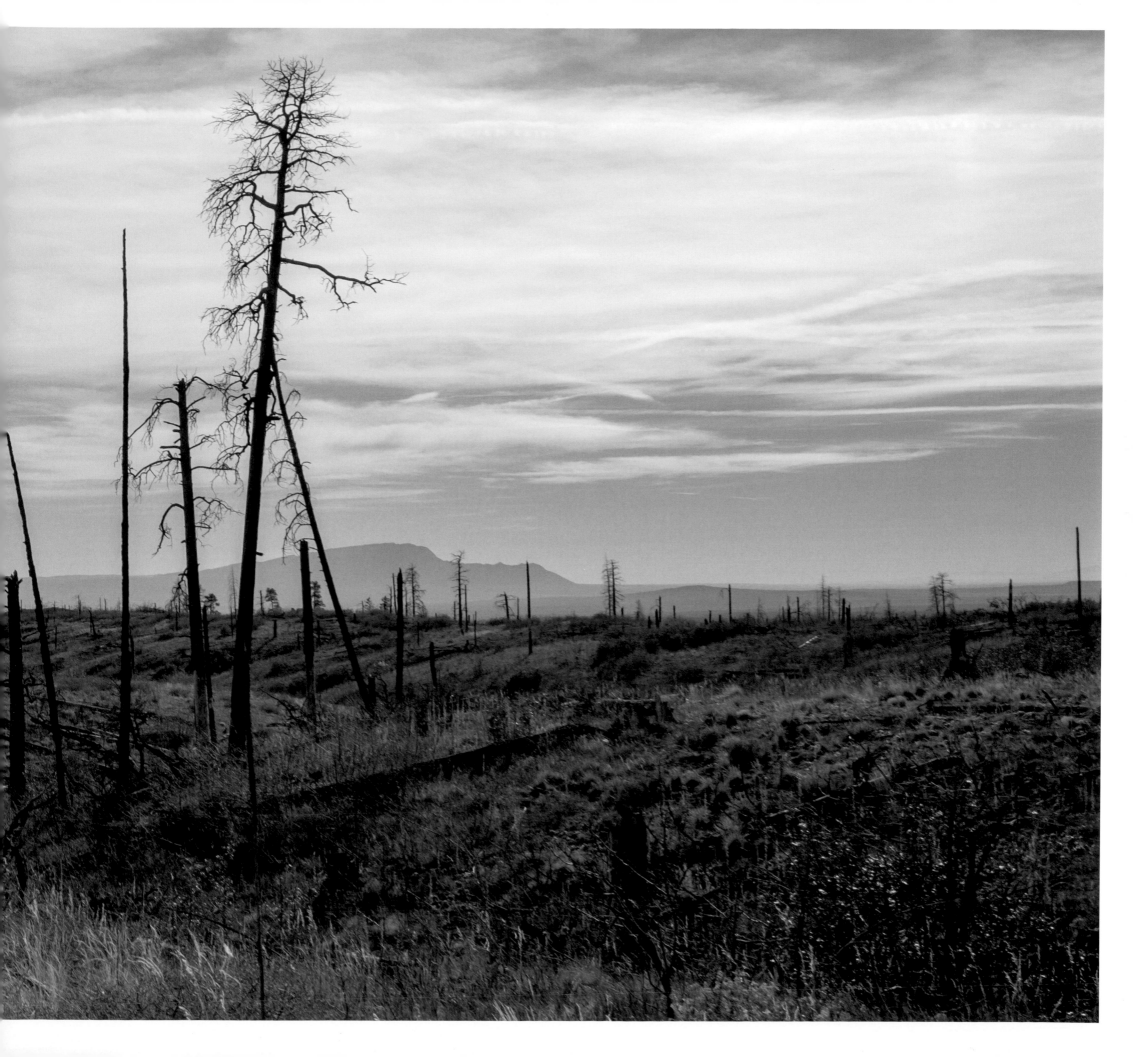

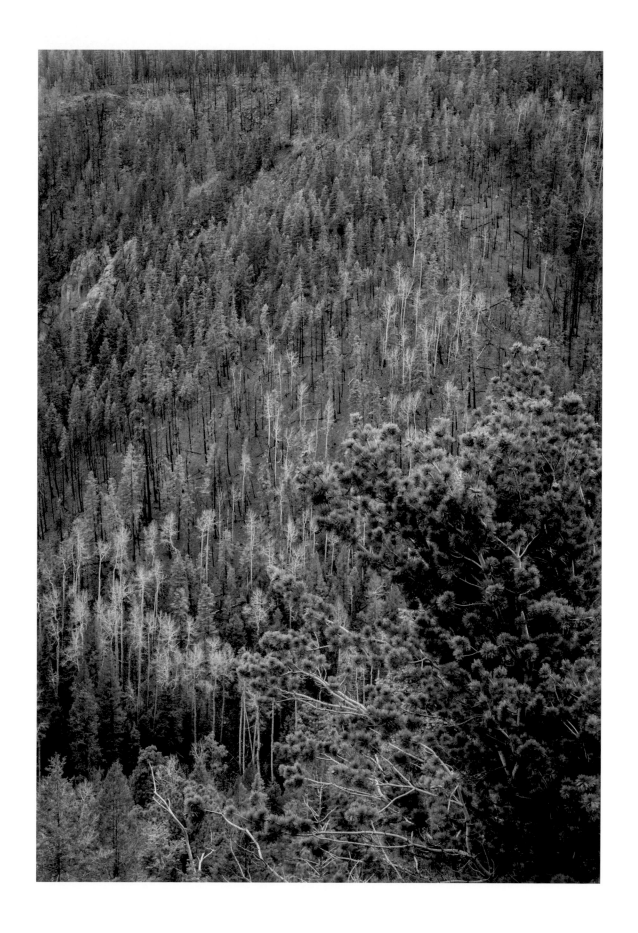

149

UPPER FRIJOLES CANYON

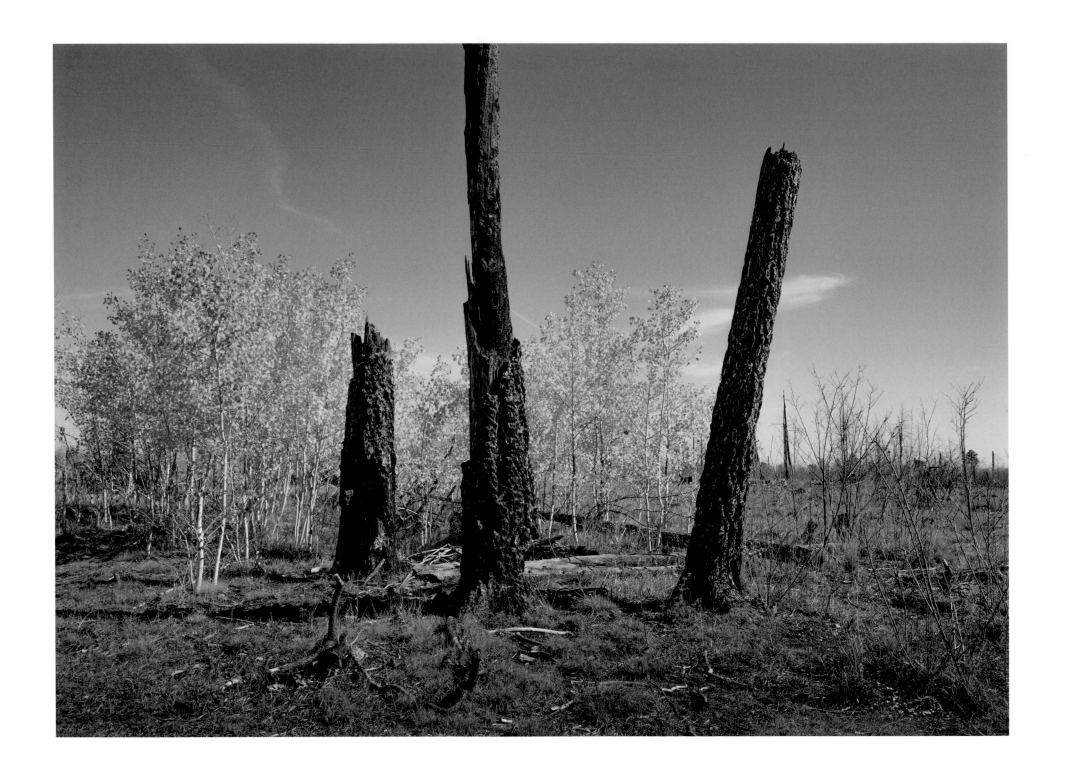

ASPENS NEAR FOREST ROAD 289

ACKNOWLEDGMENTS

WE WISH TO THANK the people who contributed to this book.

Jamey Stillings was our earliest guide, sounding-board, and helpful critic. His insights and observations about publishing were invaluable.

Four contributors to the book made the entire project more comprehensive and imbued it with a message that not only records the past, but offers a view of what the future holds for forests in an era of climate change. Thanks to Kate Ware, Bill deBuys, Craig Allen, and Carolyn Florek.

Thanks to Joanna Hurley, book designer David Skolkin, and publisher George F. Thompson. There is no substitute for the best pros in the business.

Thanks to the loyal, hard-working employees of the U.S. Forest Service and the National Park Service who care for America's wilderness. Our system of national parks, owned by citizens and open to all, is unmatched anywhere in the world. It is a unique and precious treasure.

To our many friends and supporters who helped fund the project, thank you. Special thanks to donors Fran and Jack Drew, Gavin Hurley, Dee Ann McIntyre, and Karen Novotny. This book would not have been published without your belief in the project and everyone's generous support.

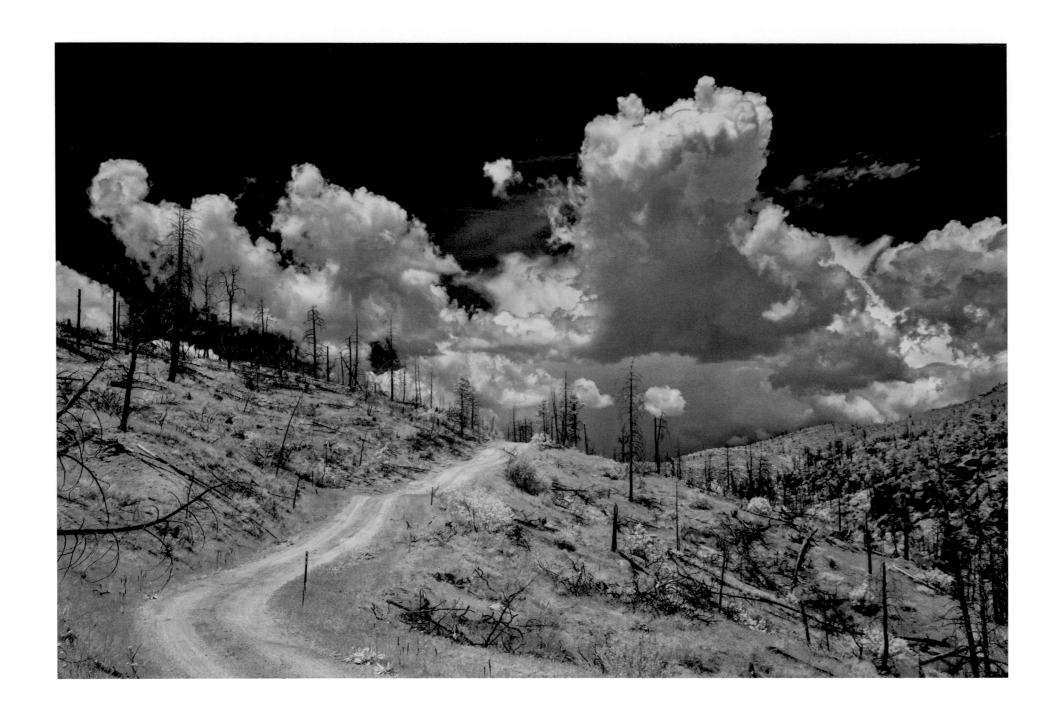

LOOKING NORTH ON FOREST ROAD 289

PATRICIA GALAGAN, born 1941 in St. Petersburg, Florida, is a fine-art photographer based in Santa Fe whose work often concerns the aftermath of upheaval, both social and environmental. Equipped with an undergraduate degree in French and a graduate degree in English, she worked for several decades as a writer and editor. Photography was a life-long avocation, which she now pursues full-time. Her photographs of the aftermath of wildfires were the subject of a solo show at photo-eye Bookstore in 2013 and part of the 2015 *Fire Season* show at the New Mexico Museum of Art. Her portraits of Cubans in their homes were shown in a solo show at the Fotografika Gallery near Geneva, Switzerland, in 2014, and at Fototeca de Cuba in Havana in 2017. She was awarded a solo show at Blue Sky Gallery in Portland, Oregon, by Photolucida in 2015. With her husband, Philip Metcalf, she was an artist-in-residence at Bandelier National Monument for a month in 2015. Her photography series from the residency, "Juniper Futures," was shown at Bandelier National Monument throughout 2016.

PHILIP METCALF, born in 1942 in Auburn, New York, is a landscape photographer who creates black-and-white infrared images. After graduating from Princeton University, he worked in banking and financial management marketing for many years. His interest in photography began as a young boy reading *Life, Look, Colliers,* and *National Geographic* magazines. At twelve, he set up a darkroom in the basement of his parents' home and has been involved as a student, collector, and practitioner of photography ever since. His passion now is to interpret nature, both pristine and altered by man, especially in the American Southwest. Increasingly, environmental concerns influence his work. In 2012, his work was included in a photography special in *Santa Fean* magazine. In 2013, his work was part of a group show at the San Diego Museum of Art. In 2014, he was a winner of *Black and White* magazine's portfolio contest, and his image was featured on the cover of the magazine. His work was also shown at the New Mexico Museum of Art in the 2015 show "Fire Season" and is included in the photo archives of the New Mexico History Museum. In 2015, he was an artist-in-residence at Bandelier National Monument in New Mexico with his wife, Patricia Galagan. His work was shown there during 2016. He has also been featured on Lenscratch and Cada día un fotógrafo/Fotógrafos en la red blogs, and his work is included in photo-eye's Art Photo Index.

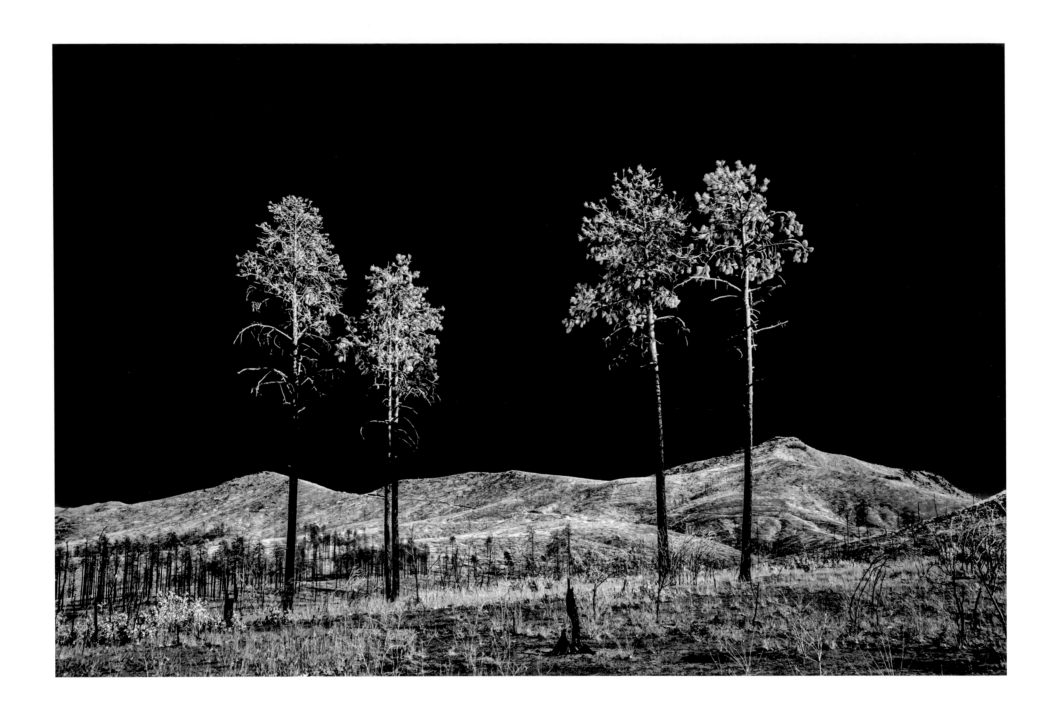

THE DOME WILDERNESS
Following spread (pages 156-57): GAMBEL OAK SUPPLANTING PONDEROSA PINES

CRAIG D. ALLEN is a research scientist with the New Mexico Landscapes Field Station of the U.S. Geological Survey, based in his beloved Jemez Mountains, where he has raised a family and conducted ecological research since 1981. He does place-based, long-term research on the ecology and environmental history of Southwestern landscapes, and the responses of Western mountain ecosystems and forests globally to climate change, with numerous international collaborations. His office has always been co-located with land managers at Bandelier National Monument, reflecting his commitment to provide scientific and technical support to diverse land-management agencies, Native American tribes, and governmental and non-governmental organizations.

WILLIAM DEBUYS is a conservationist and writer whose nine books include *The Last Unicorn: A Search for One of Earth's Rarest Creatures* (Little, Brown, 2015 and 2016), *A Great Aridness: Climate Change and the Future of the American Southwest* (Oxford University Press, 2011 and 2013), and, with photographer Alex Harris, *River of Traps: A Village Life* (University of New Mexico Press, 1991; Trinity University Press, 2009), which was a finalist for the 1991 Pulitzer Prize. From 2001 to 2004 deBuys chaired the Valles Caldera Trust, which administered the 89,000-acre Valles Caldera National Preserve in the Jemez Mountains of northern New Mexico. As a conservationist, he has helped protect more than 150,000 acres in New Mexico, Arizona, and North Carolina.

KATHERINE WARE is Curator of Photography at the New Mexico Museum of Art, where she has curated more than thirty exhibitions, including the exhibition, book, and website *Earth Now: American Photographers and the Environment* (Museum of New Mexico Press, 2011). She previously served as Curator of Photographs at the Philadelphia Museum of Art, where she was curator and author of *Elemental Landscapes: Photographs by Harry Callahan* (2001). Ms. Ware served as Assistant Curator in the Department of Photographs at the J. Paul Getty Museum during the 1990s and organized the traveling exhibition, *A Practical Dreamer: The Photographs of Man Ray* and the exhibition *Vision in Motion: The Photographs of László Moholy-Nagy*. She is a frequent juror and reviewer of contemporary photography.

CAROLYN TOURNEY FLOREK is a poet, painter, and publisher. She is the author of *Time at Bandelier: A Month in Frijoles Canyon* (Cardinal Press, 2016), an illustrated journal of her time as an artist-in-residence at Bandelier National Monument in New Mexico in 2015. Her paintings of Bandelier were shown in a solo show at the Fuller Lodge Art Center in Los Alamos, New Mexico, in 2017. Her poetry has been published in *The Texas Review, Illya's Honey*, and several Houston Poetry Fest anthologies. Her poem, "Over Flat Creek," was nominated for a Pushcart Prize in 2014. She is a co-founder, with her husband, Robert Florek, of Metabilis Press, a non-profit publisher of the work of regional poets in and near Houston, Texas.

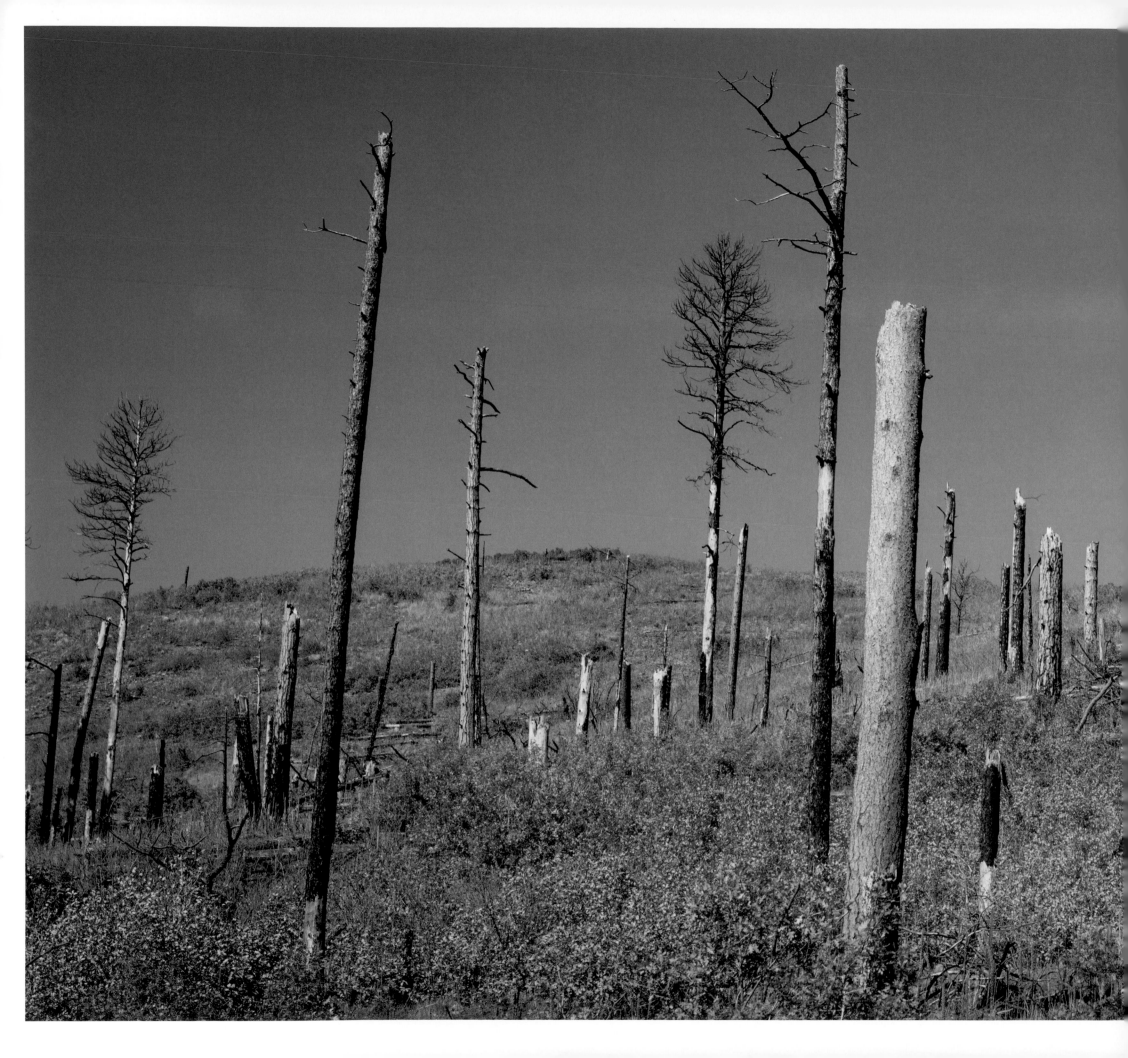

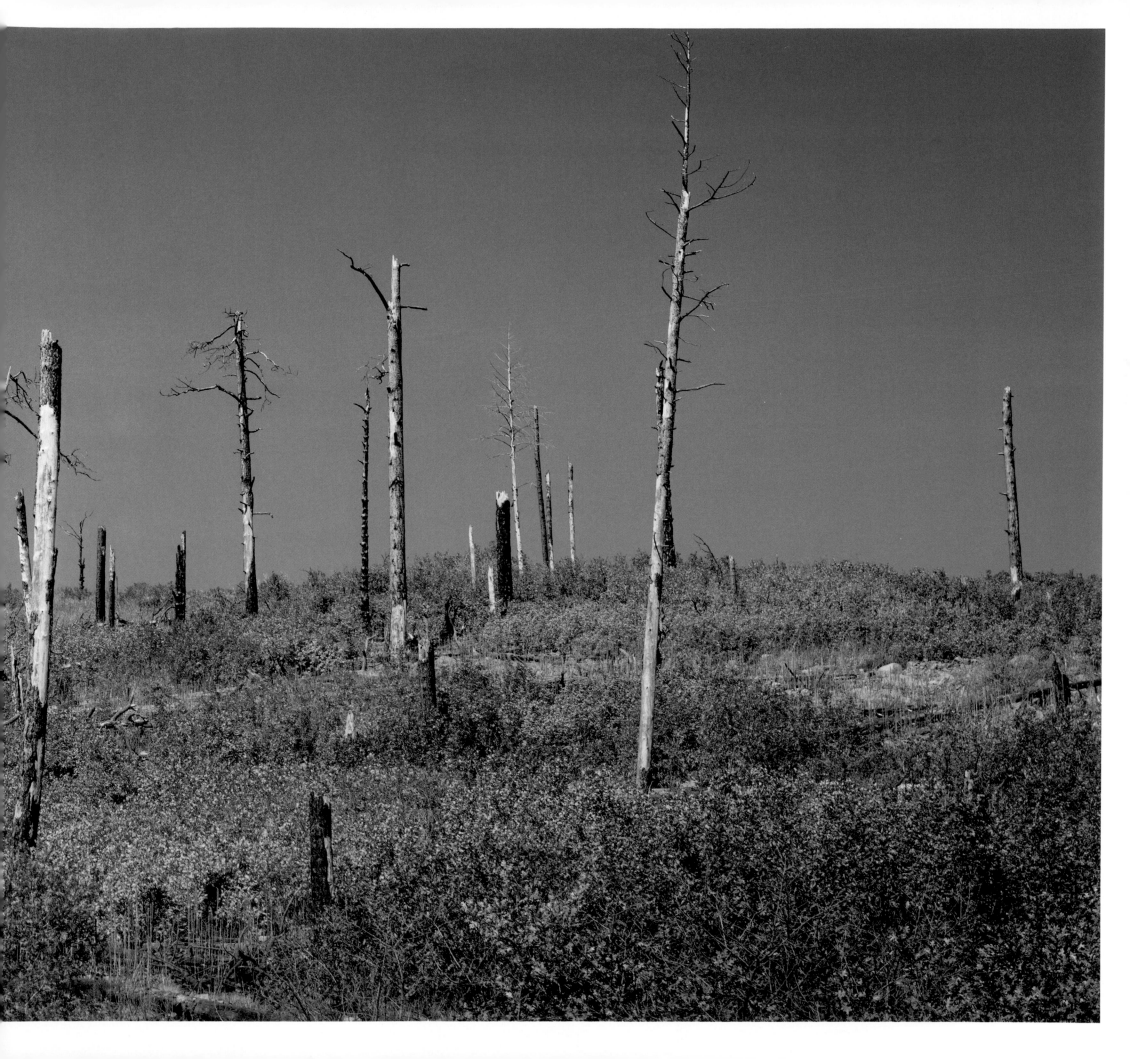

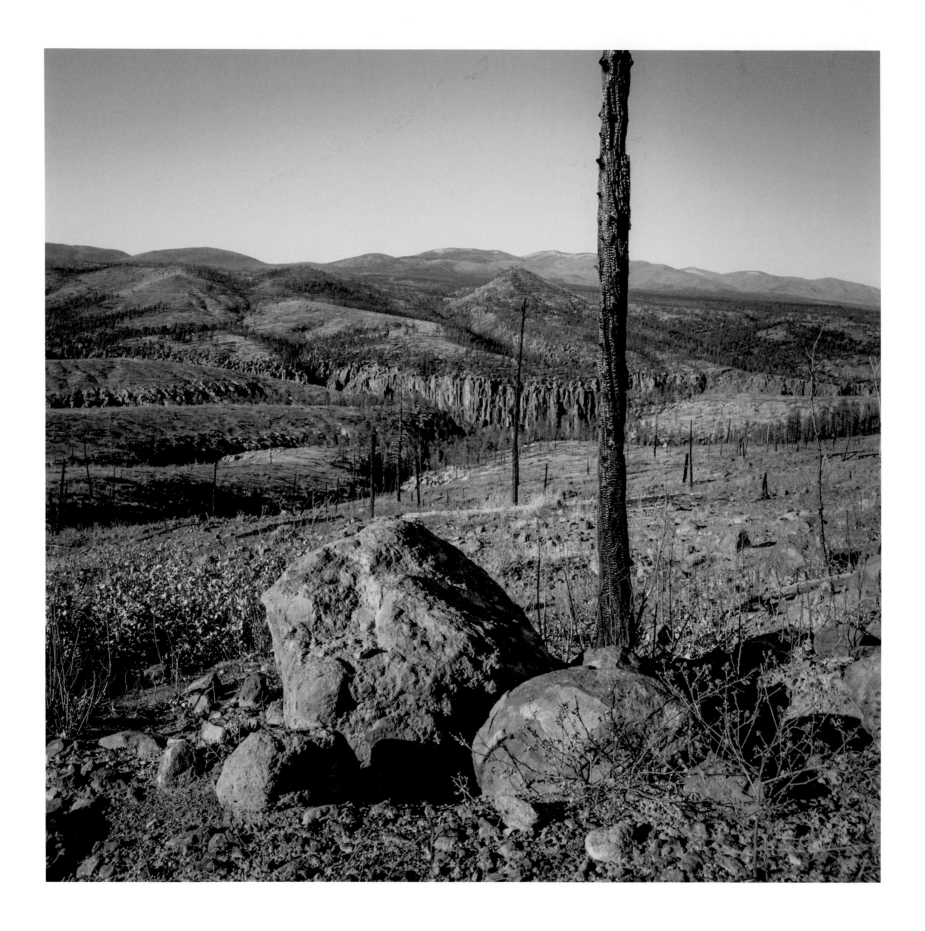

CAPULIN CANYON

ABOUT THE BOOK

Fire Ghosts was brought to publication in an edition of 1,000 copies. The type was set in Aldus and Berthold Akzidenz Condensed, the paper is 150 gsm Condat Perigord matt, and the book was professionally printed and bound in Singapore by Pristone Pte. Ltd.

The epigraph on page 21 is widely attributed to Elliott Erwitt (b. 1928), but there is no known source or date; see https://www.goodreads.com/author/.

The epigraph on page 89 was first published in Dylan Thomas, *18 Poems* (London, UK: *The Sunday Referee* and Parton Bookshop, December 1934), 10.

Publisher: George F. Thompson
Project Manager and Editor: Joanna T. Hurley, of HurleyMedia, L.L.C.
Editorial Assistant: Mikki Soroczak
Proofreader: Purna Makaram
Book Design and Production Director: David Skolkin

Published in 2019. First hardcover edition.
Printed in Singapore on acid-free paper.

George F. Thompson Publishing, L.L.C.
217 Oak Ridge Circle
Staunton, VA 24401-3511 U.S.A.
www.gftbooks.com

27 26 25 24 23 22 21 20 19 1 2 3 4 5

The Library of Congress Preassigned Control Number is 2019942921

ISBN: 978–1–938086–71–7

FRONT COVER: COCHITI CANYON
BACK COVER: LOST PINES NEAR COCHITI CANYON
PAGES 2–3: PONDEROSA CAMPGROUND, BANDELIER NATIONAL MONUMENT
PAGES 4–5: WINTER, OBSIDIAN RIDGE